Cats Are Like That

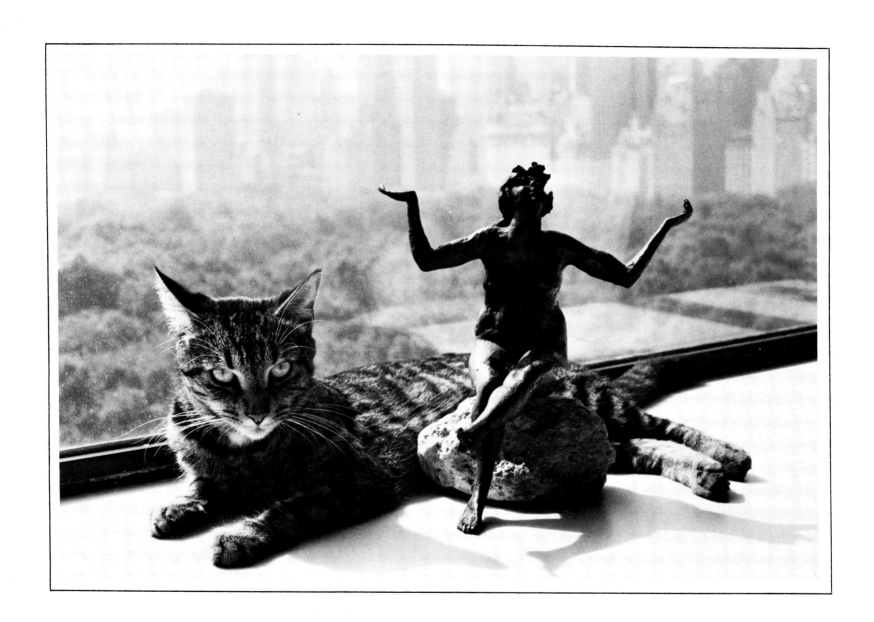

JOAN BARON

Cats Are Like That

1817

HARPER & ROW, PUBLISHERS, New York

Cambridge, Philadelphia, San Francisco, London, Mexico City, São Paulo, Singapore, Sydney

by the same author CAT COUPLES

FIRST EDITION

Designed by Ruth Bornschlegel

Library of Congress Cataloging in Publication Data

Baron, Joan.
 Cats are like that.

 1. Cats—Pictorial works. I. Title.
SF446.B38 1984 779′.32 83-48935
ISBN 0-06-091148-4 (pbk.)

84 85 86 87 88 10 9 8 7 6 5 4 3 2 1

For Abby, Lizzy, Jimmy and Mike

Ben and Rebecca

Acknowledgments

I want to thank my editor Larry Ashmead for giving me the title and his trust; Abby Baron Morrison and Terry Johnson Baron for the best scouting and the lightest touch on location; all the cat people who invited me into their homes, especially Poeia Farcy who gave me the key to Loufi and the kittens; Howard Baron for his superb equipment; and most of all, God, for making the cat.

Introduction

We humans have always been involved in a kind of ambivalent romance with cats. Over time, we have feared and condemned them; we've admired and worshiped them; and to ensure keeping them close, we've chiseled, molded, sketched, etched, painted, woven, embroidered, inscribed and otherwise worked their likeness—good or bad—into every form we could manage.

Even now, a love them or hate them attitude persists along with the conviction that those of us who live with a cat or two are all a little bit daft.

In fact, what we do have in common, those of us who are fortunate enough to live with cats, is a tendency to be pretty smug about it. We're the ones with a little magic in our lives; we're the ones who know the cat's subtle powers to entertain, to soothe, and to make us feel selected.

What else do we need to say about cats? They're amusing, supple, androgynous and loving. They're also instinctive, seductive, independent, graceful and lethal. We know more too, but sometimes to describe an aesthetic ideal is to diminish it. So, for now, it's nice to let contradictions abound, it's nice to be around some magnificently complex beings that we can never fully understand, and it's nice to make a picture book that says . . . cats are like that.

Cats are perfect mothers,
they even know when to let go.

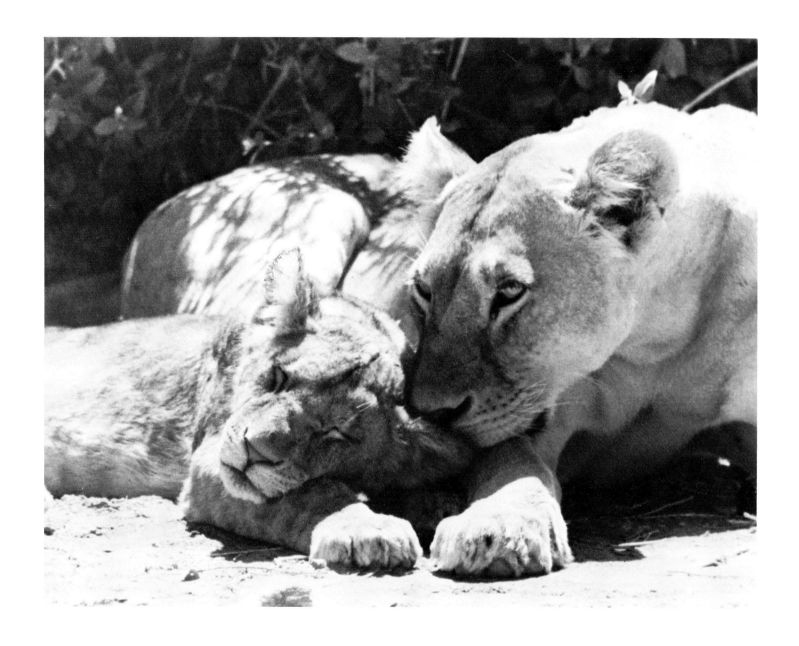

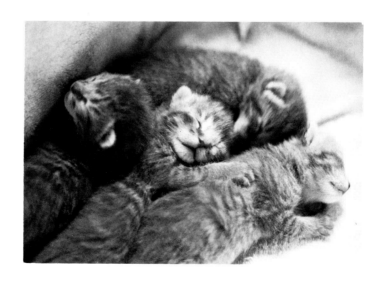

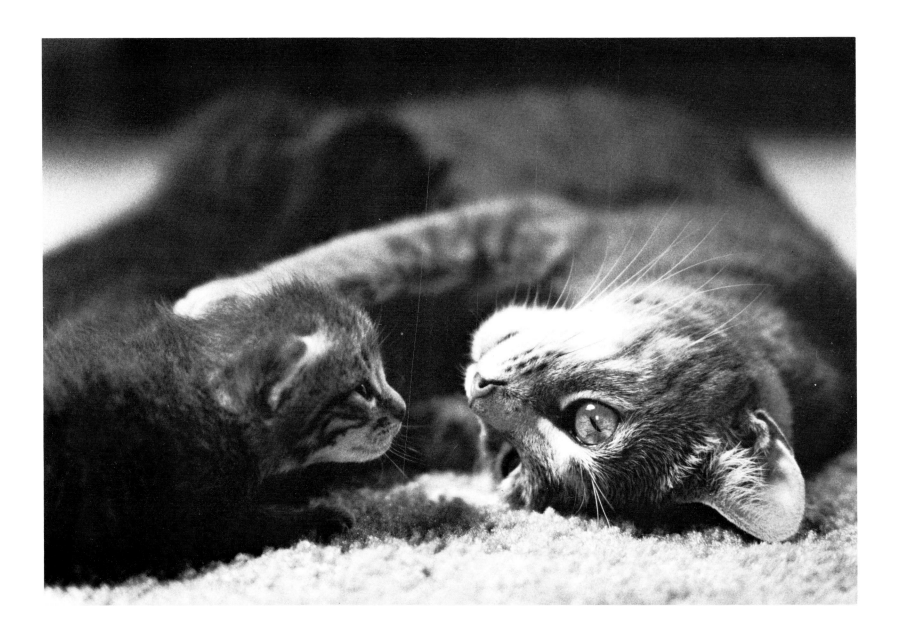

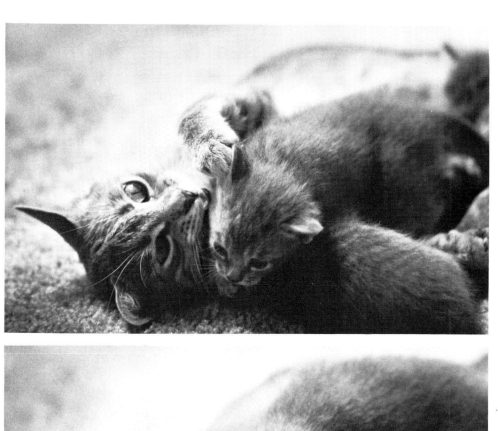
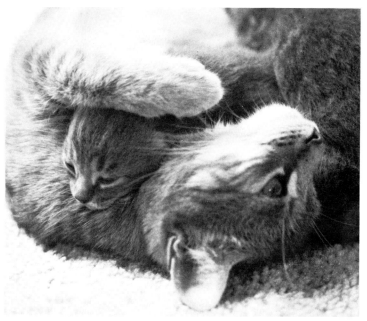
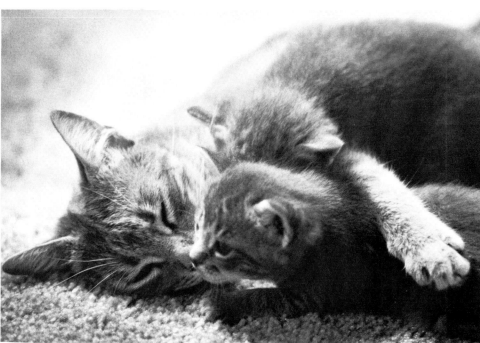
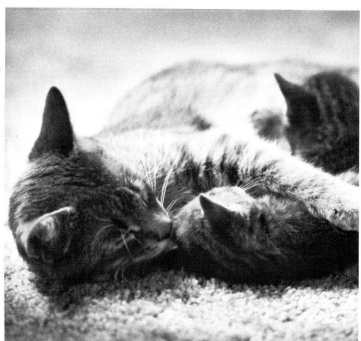

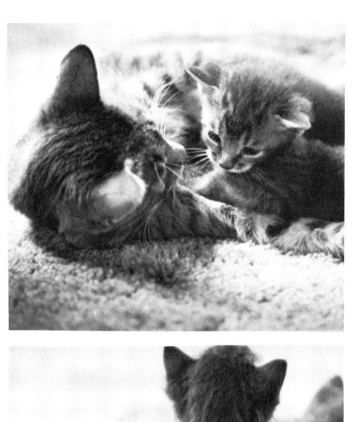
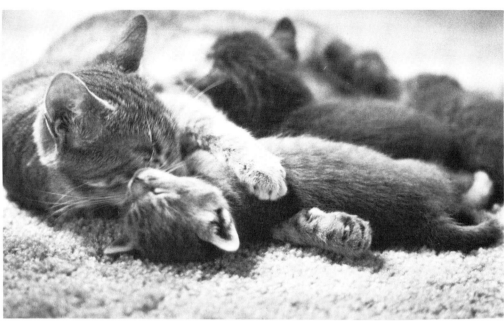
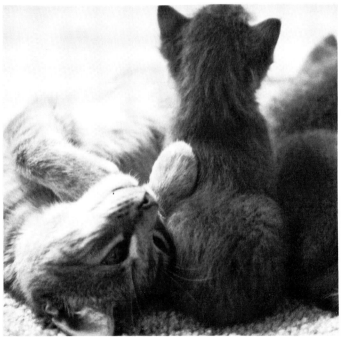
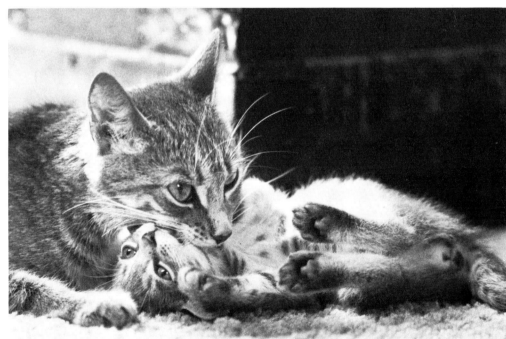

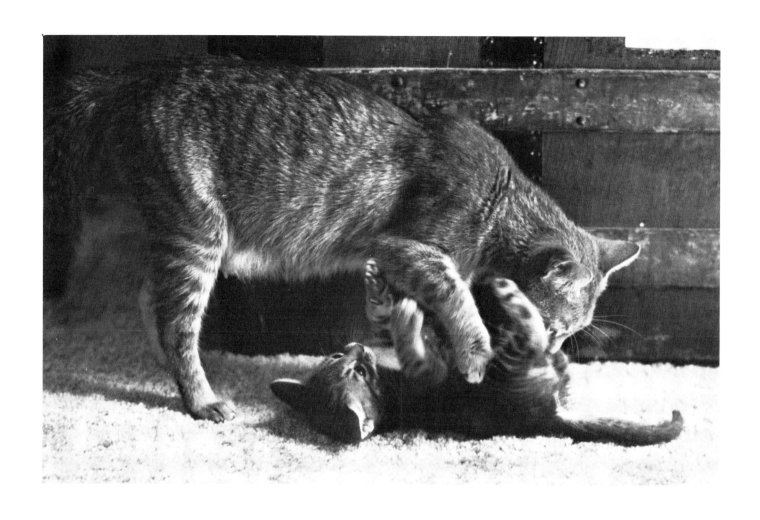

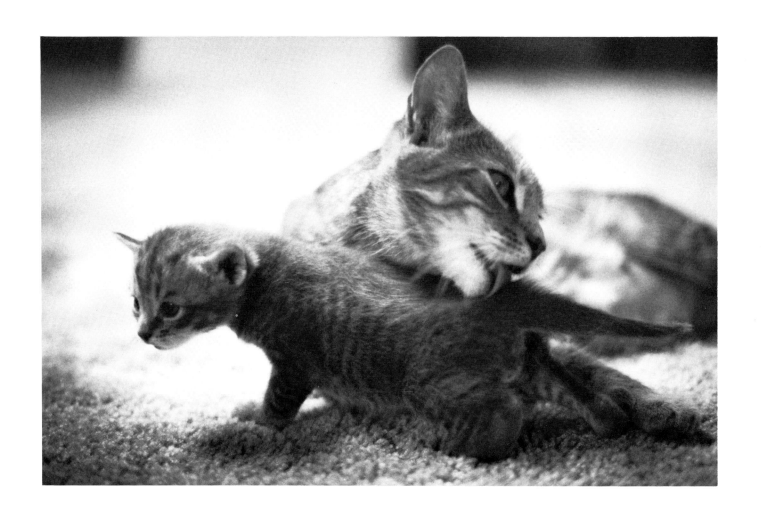

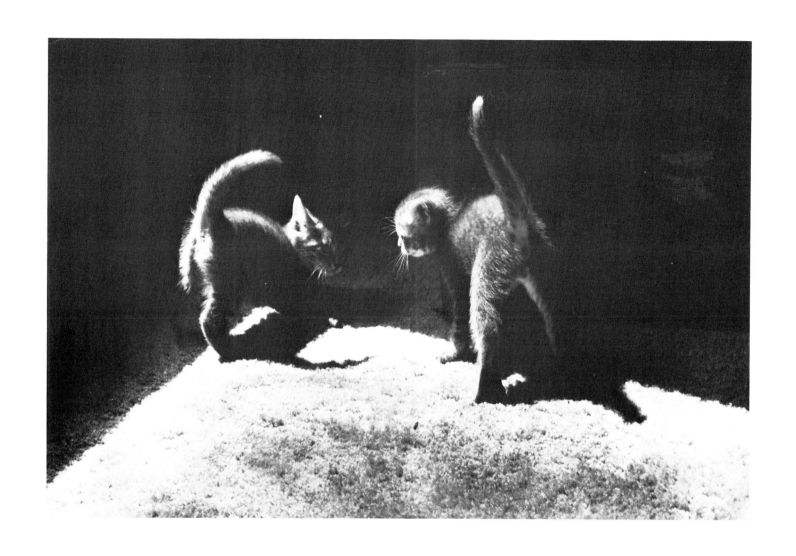

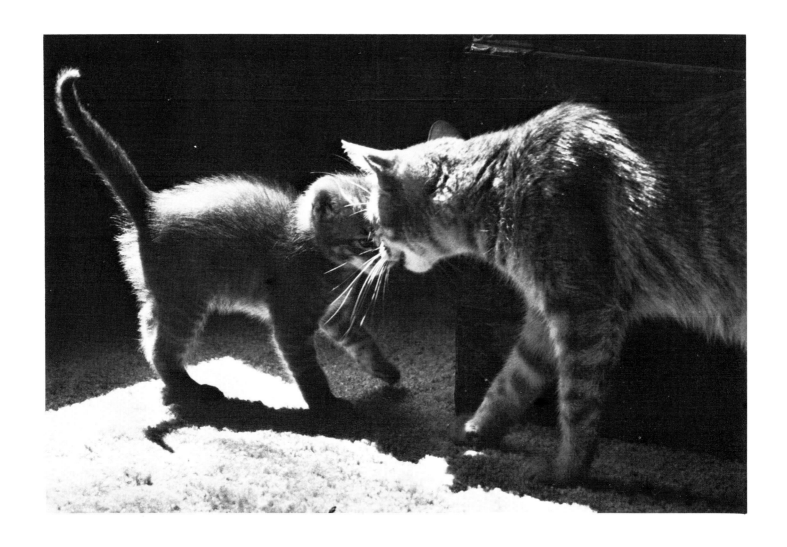

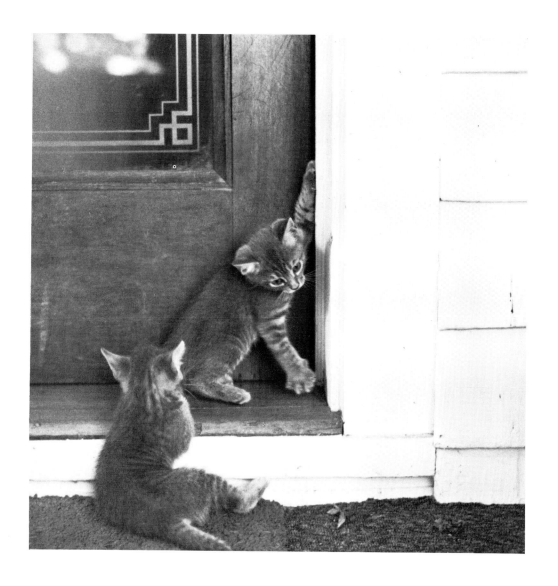

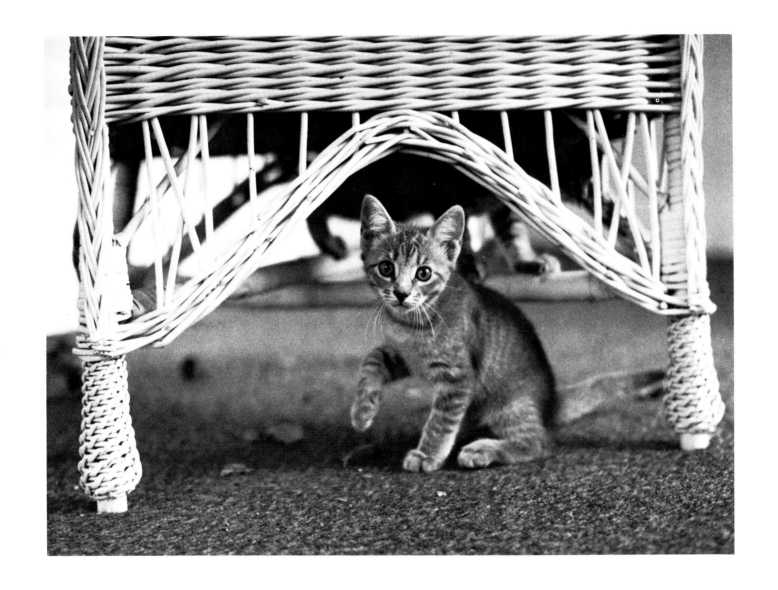

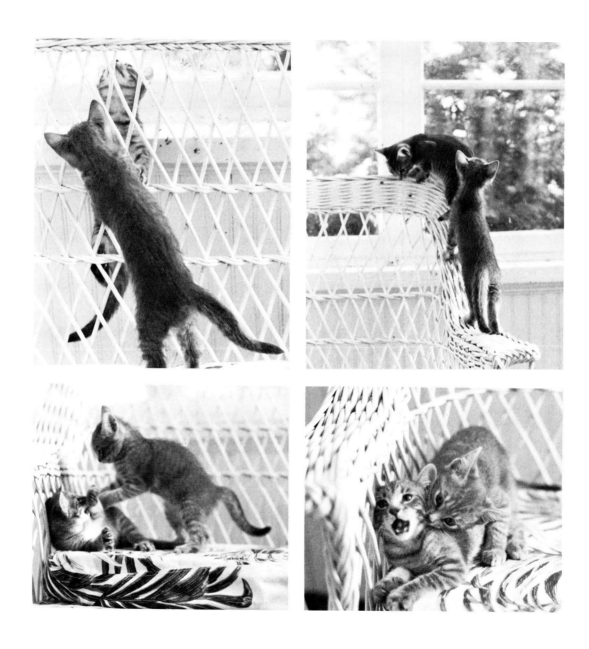

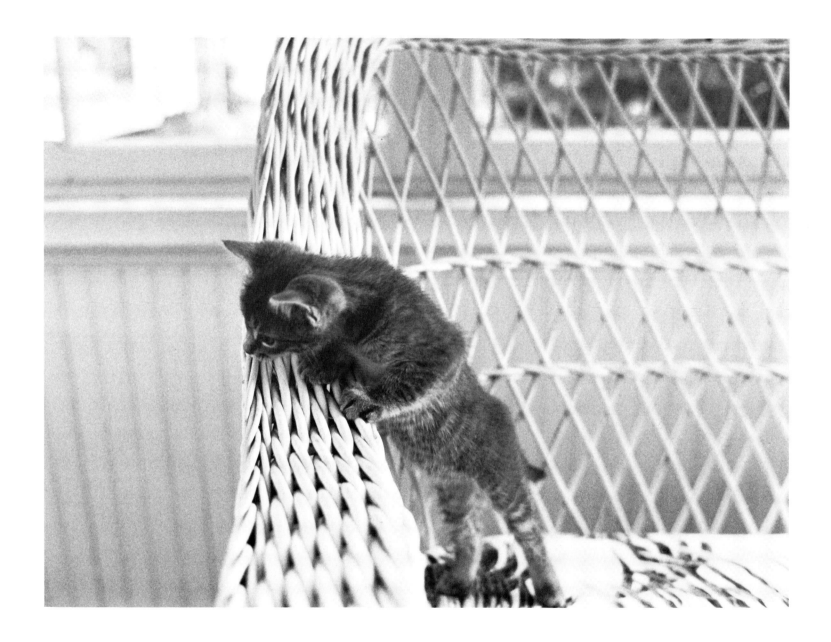

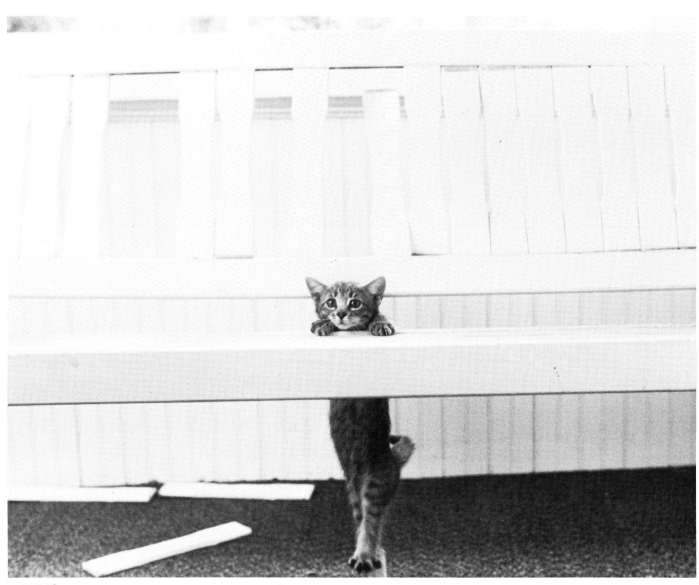

WOOFI

ADELAIDE

A space is for a cat to squeeze through.

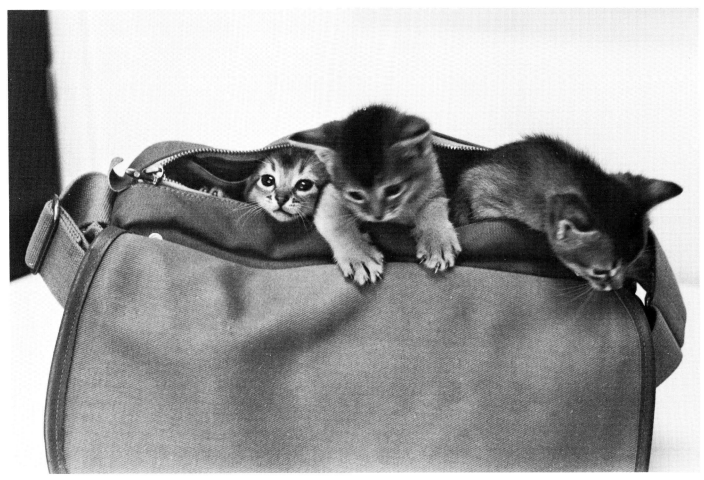

HUDSON, ADELAIDE and WINCHESTER

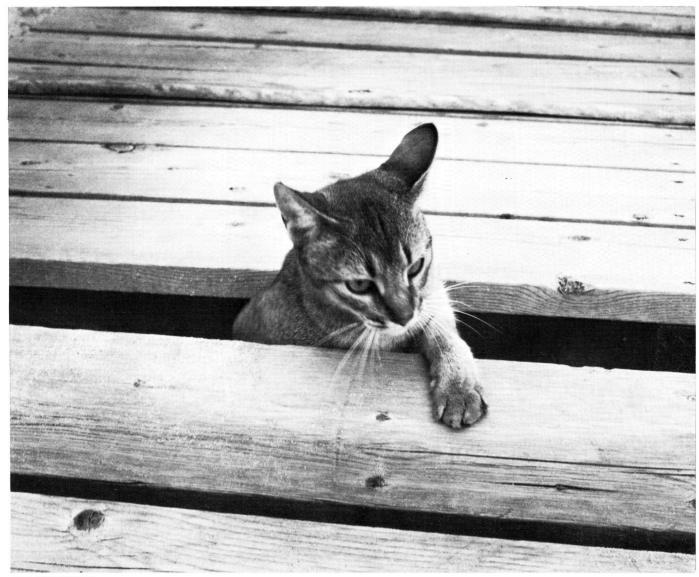

WINCHESTER

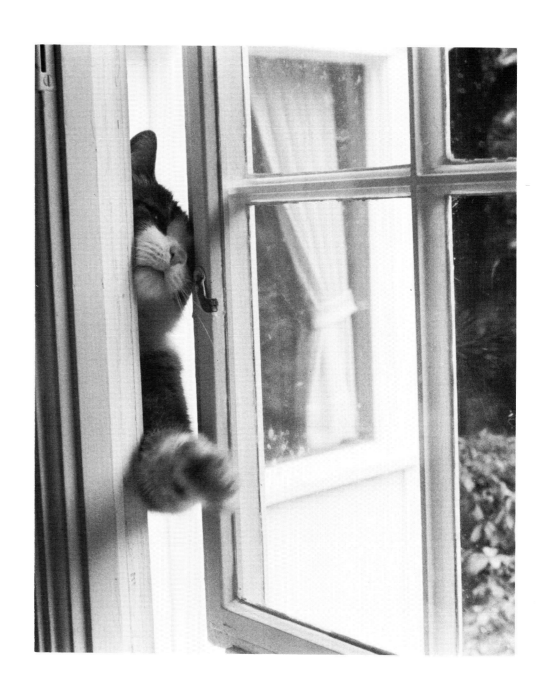

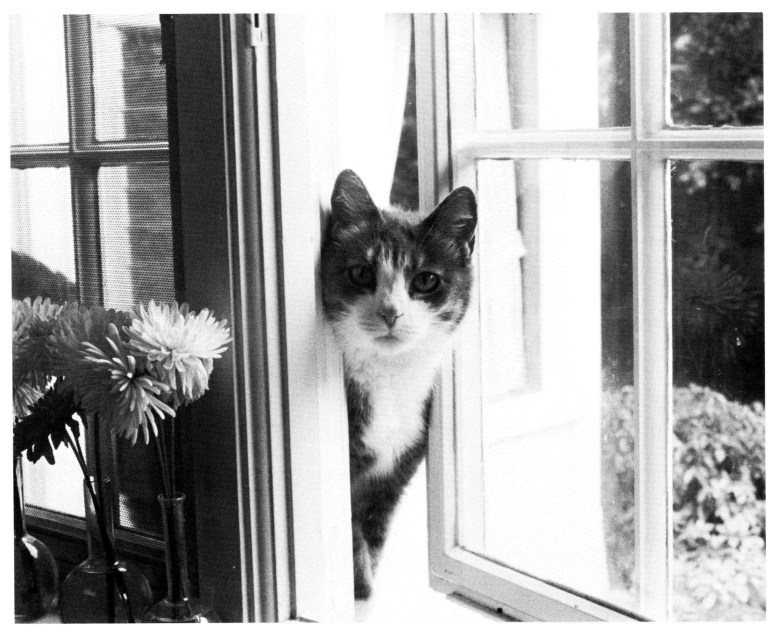

VISITOR

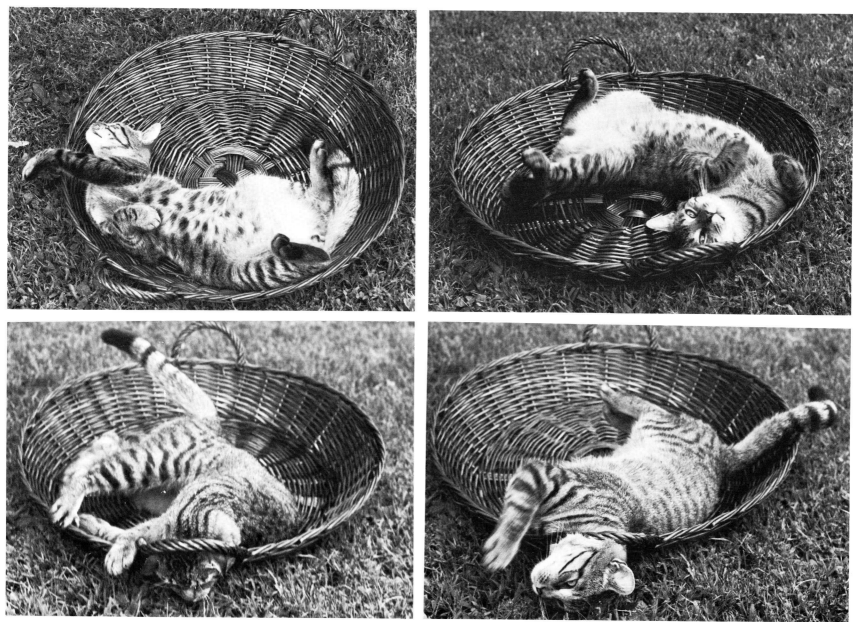

STRANGER

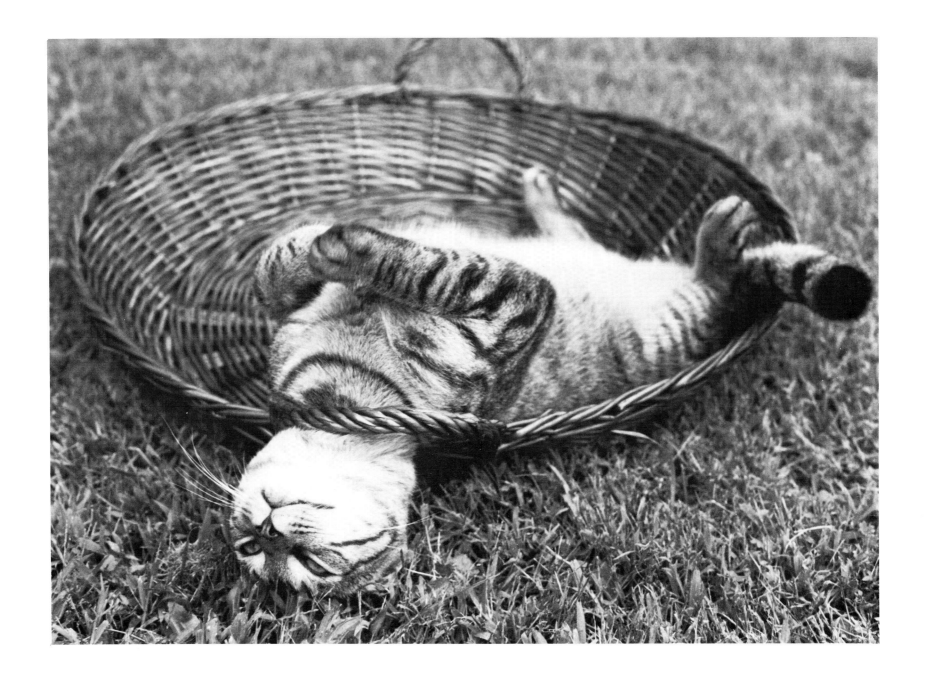

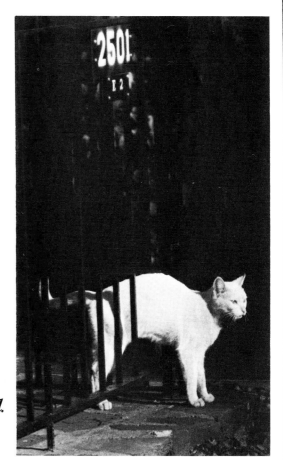

For showing off, fences make the ideal foil.

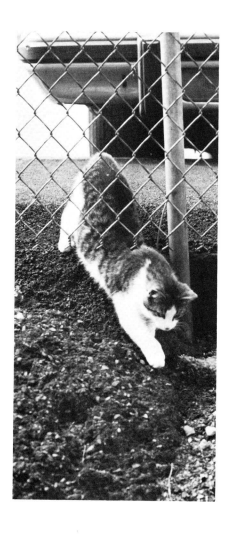

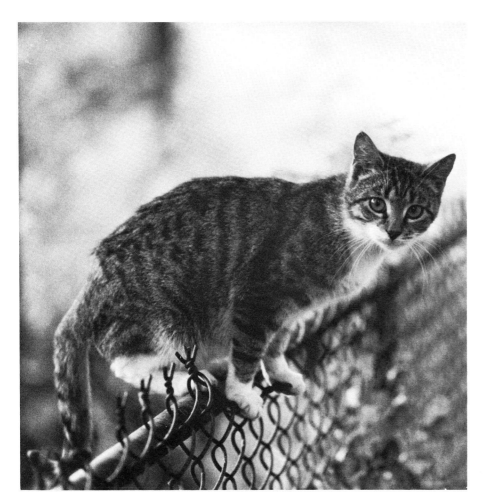
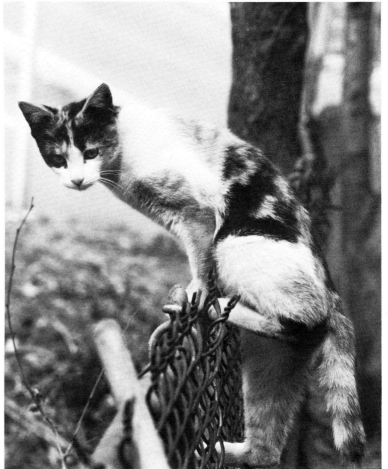

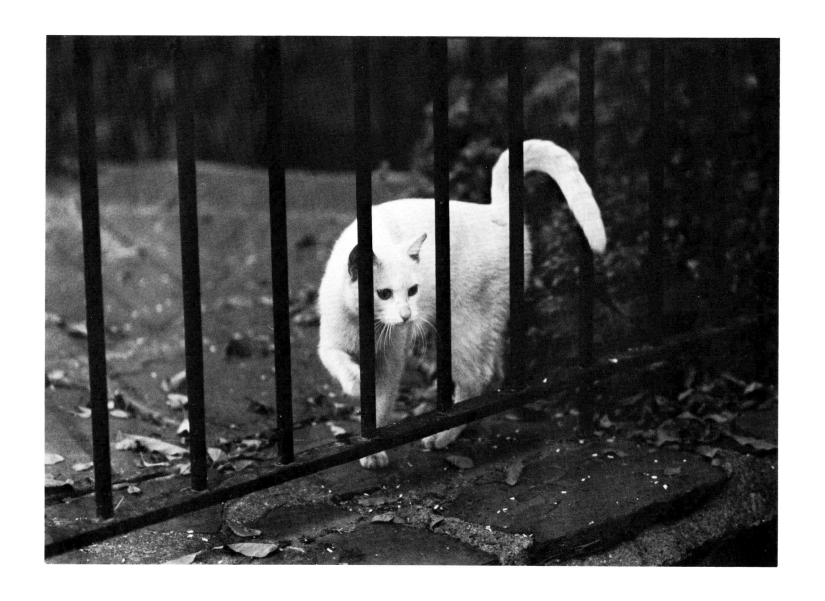

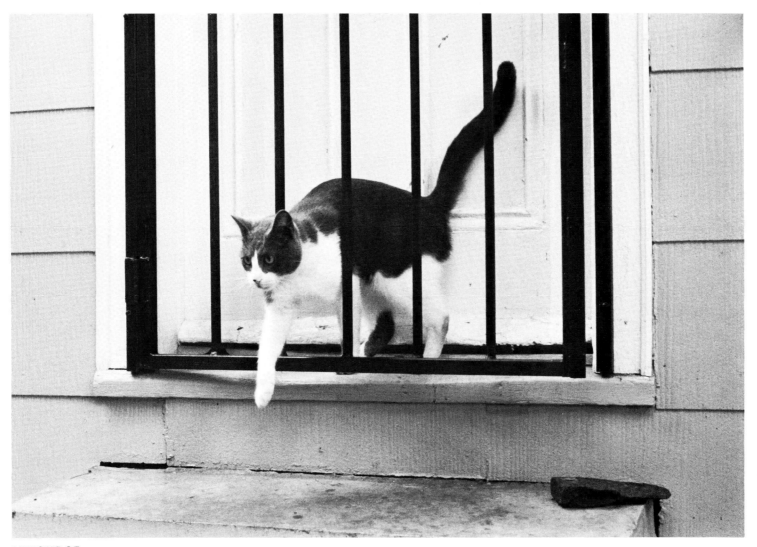

NEIGHBOR

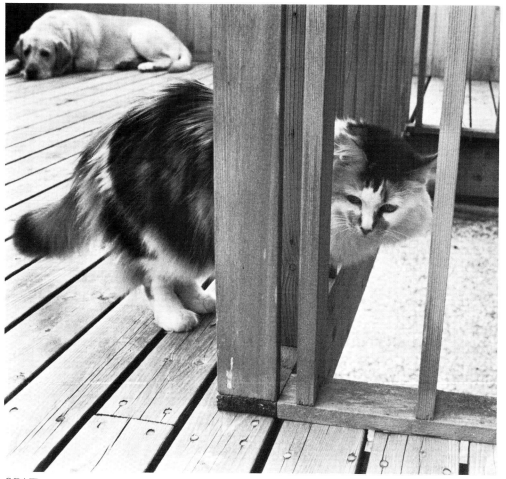

SCAT

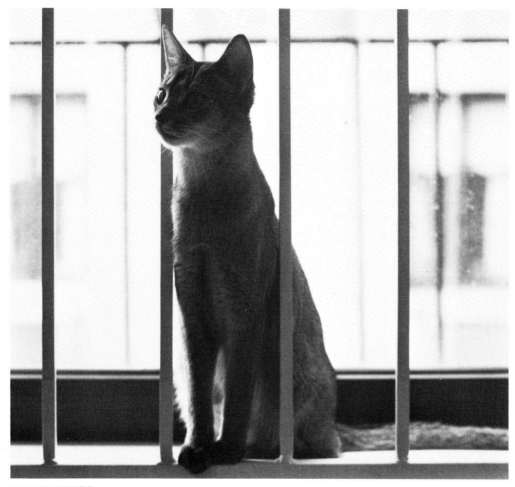

WINCHESTER

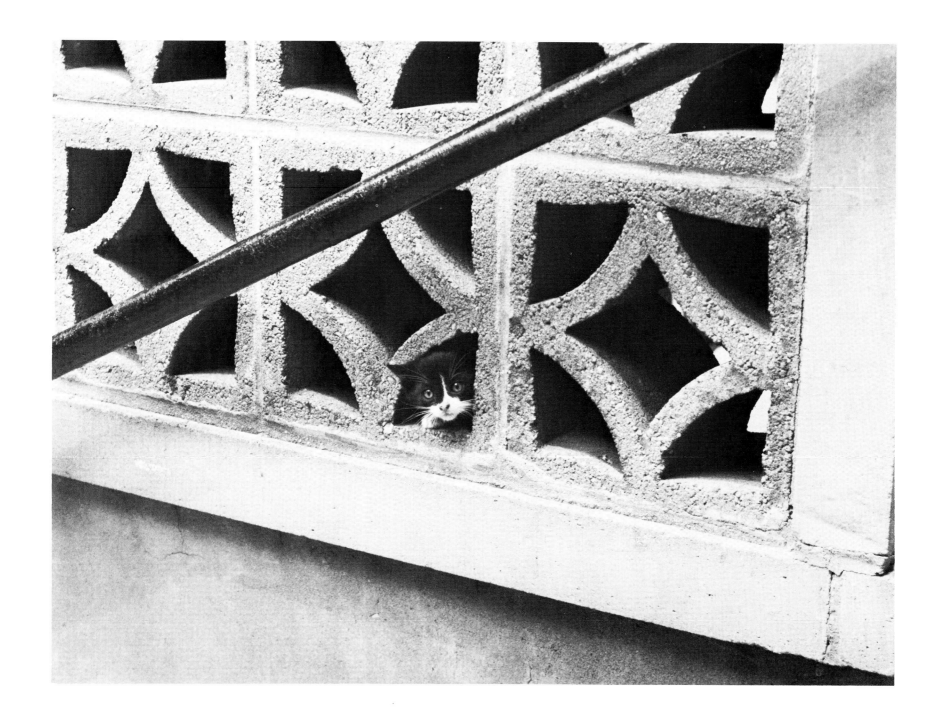

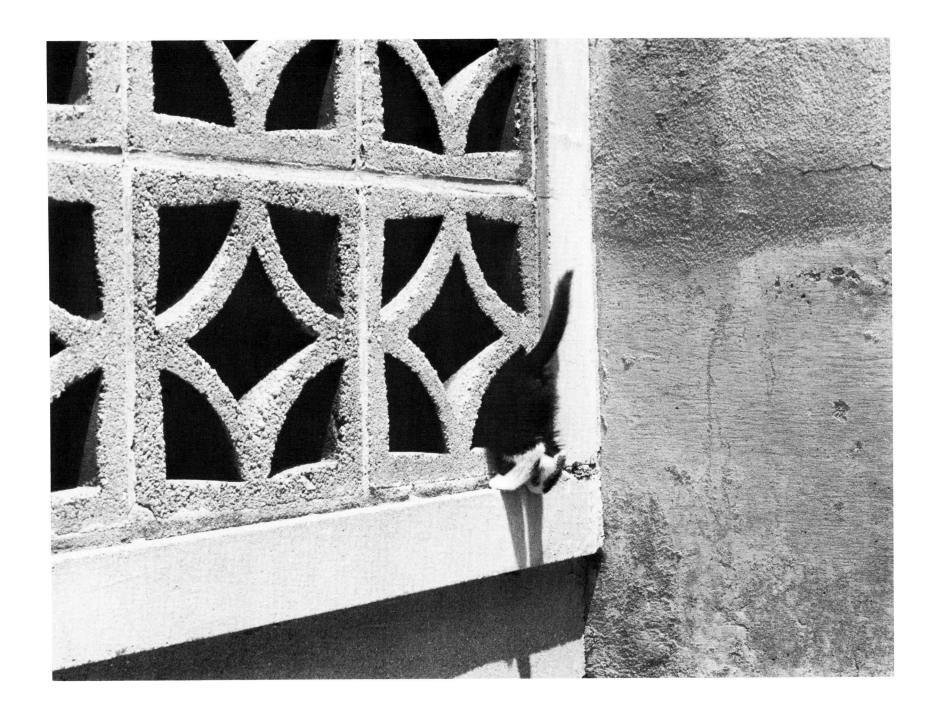

Every cat's a peeping tom.

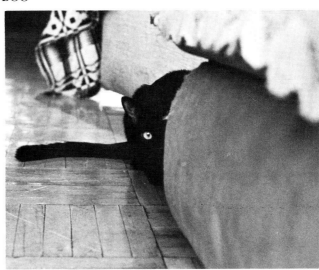

BOO

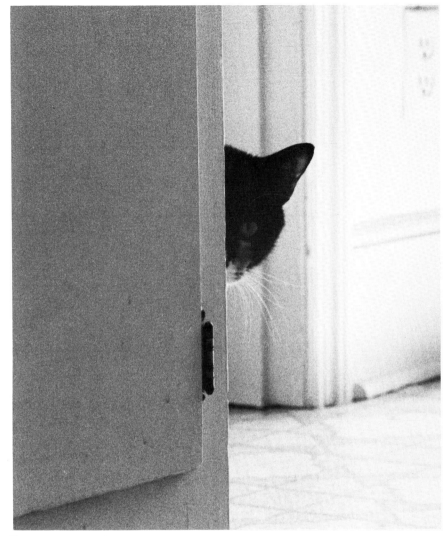

C$_2$

FERNANDO

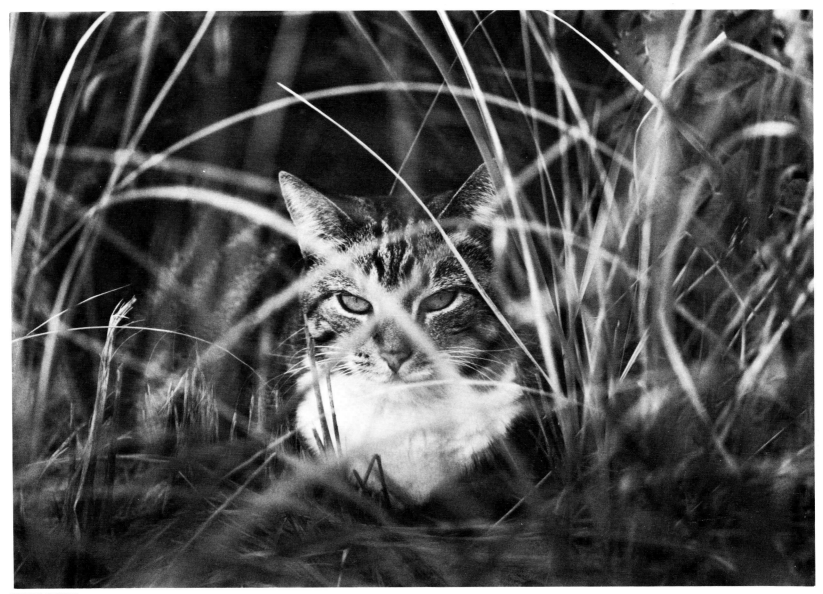

PUTSCHKE

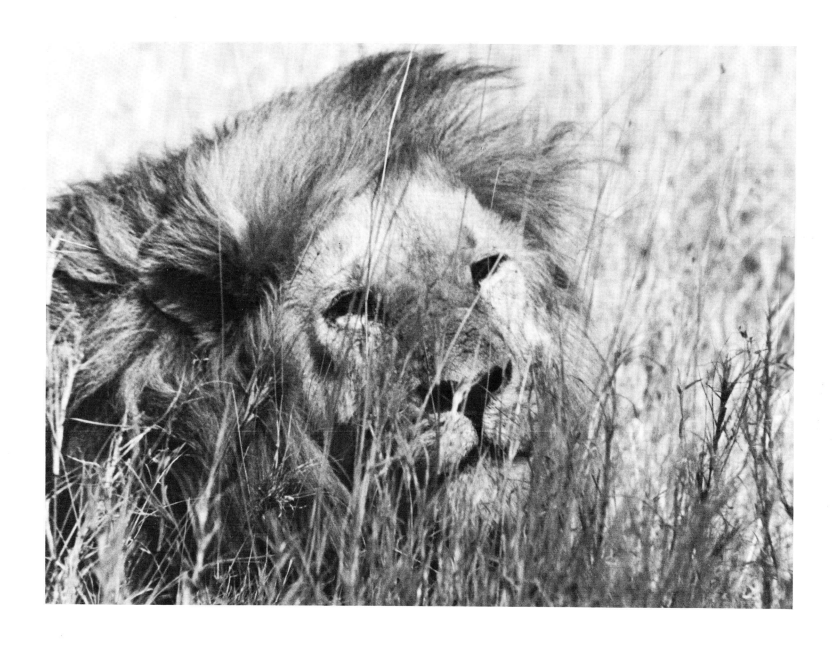

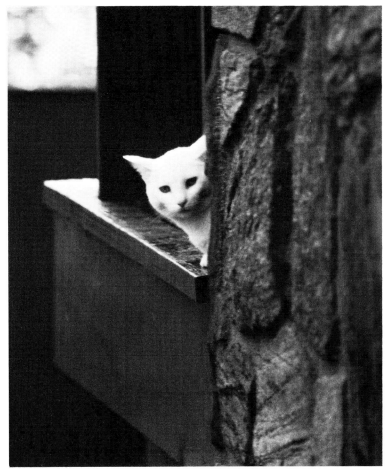

SNOWFLAKE

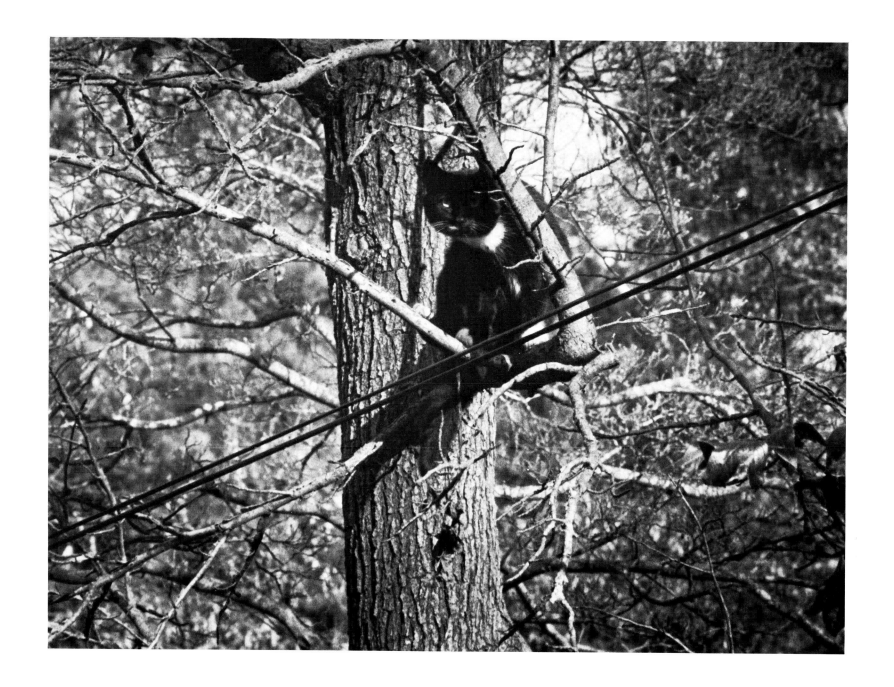

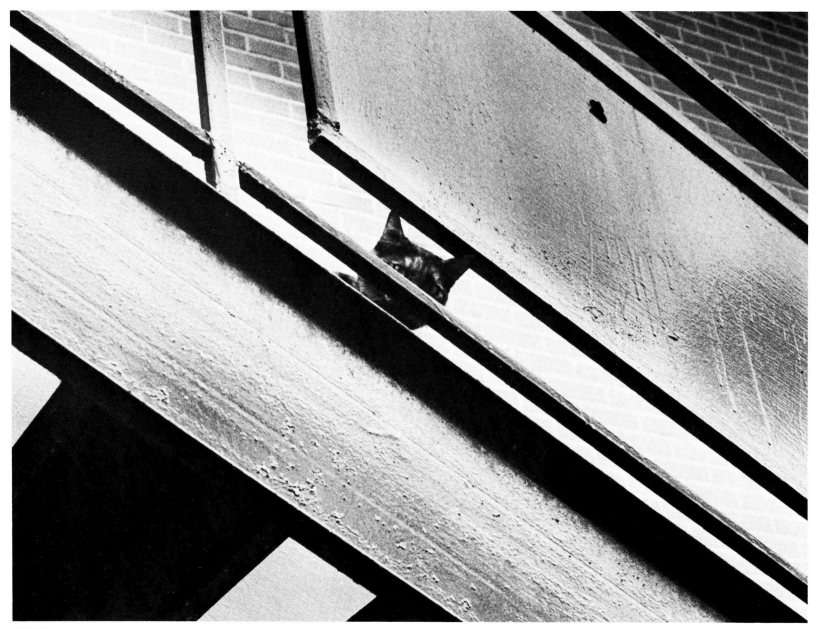

ARLO

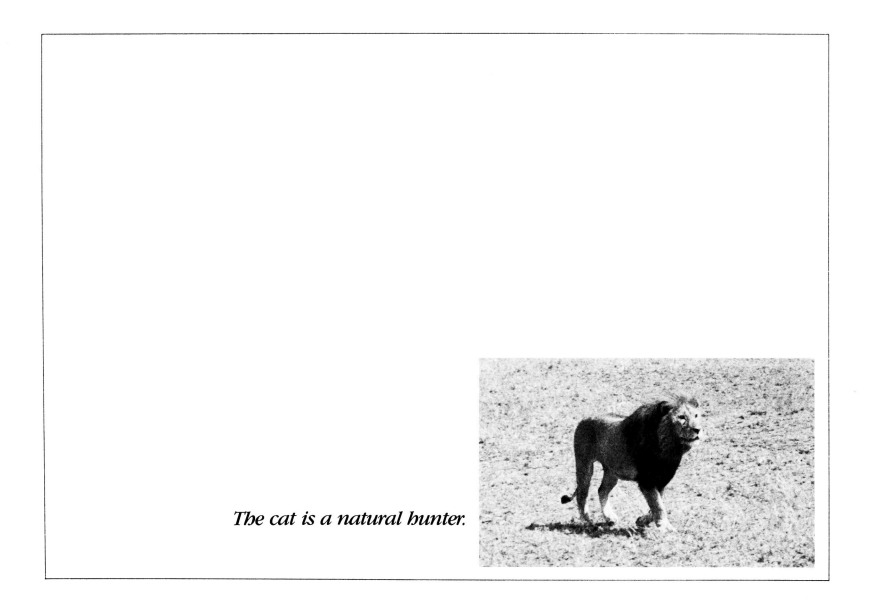

The cat is a natural hunter.

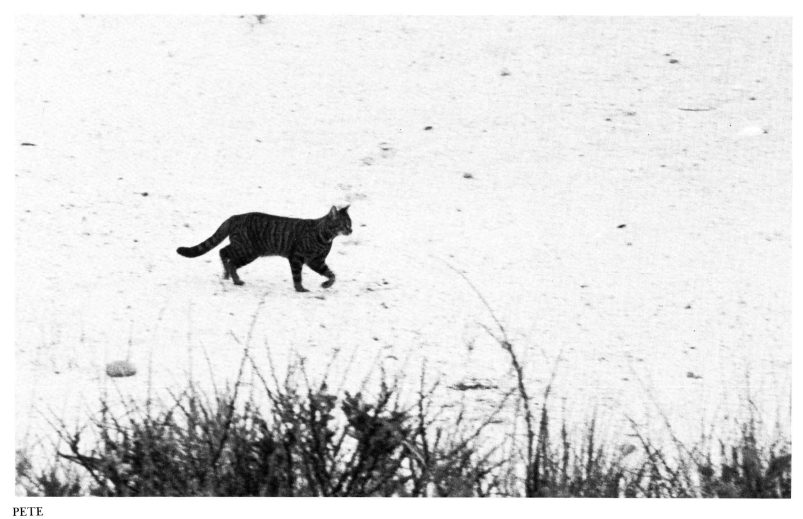

PETE

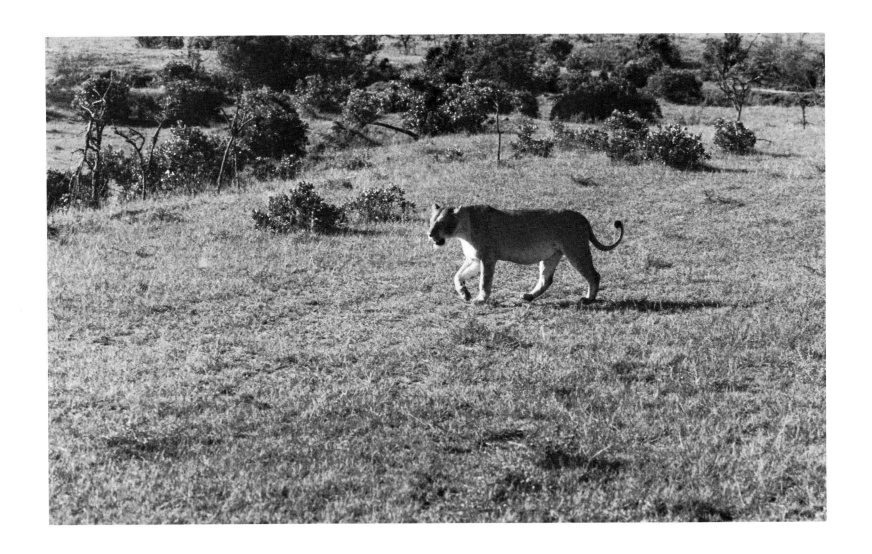

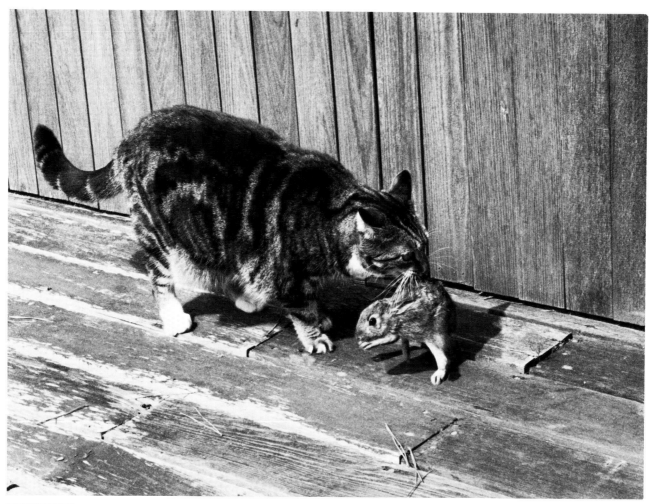

PUTSCHKE

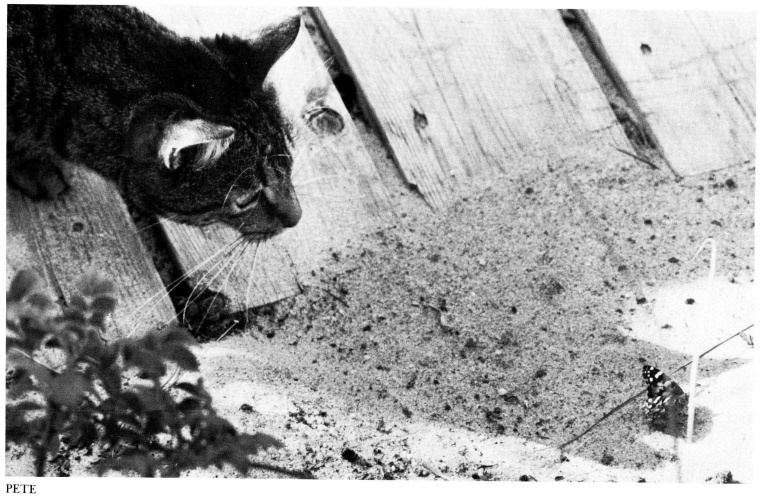

PETE

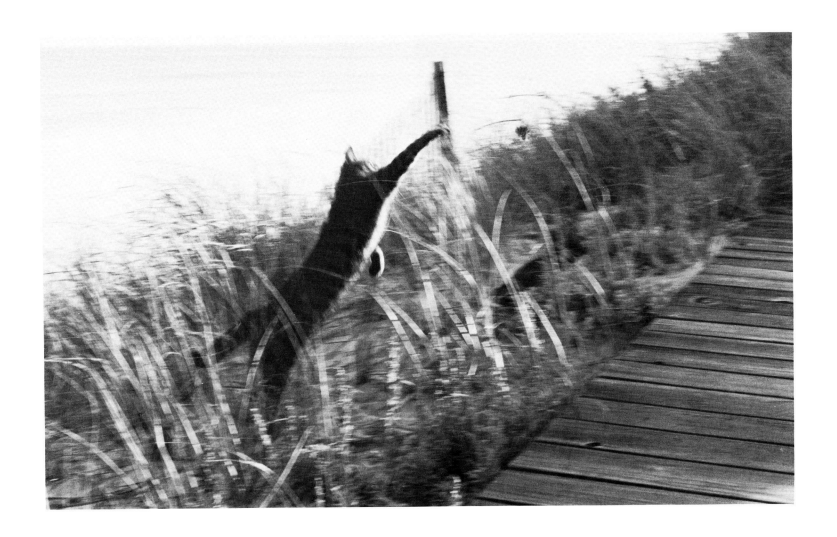

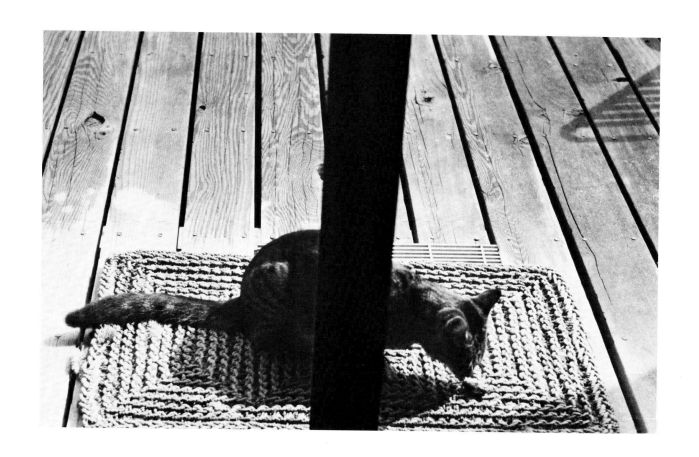

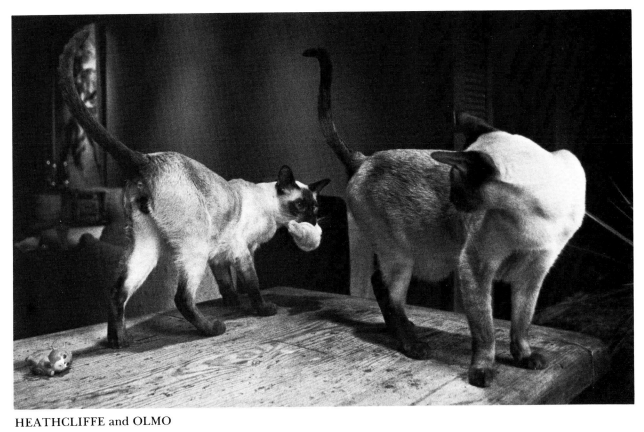

HEATHCLIFFE and OLMO

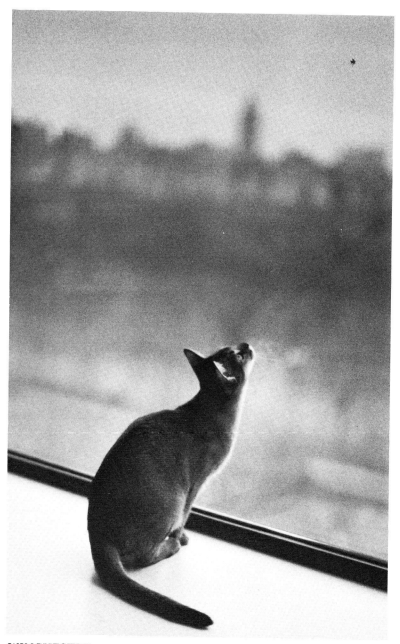

WINCHESTER

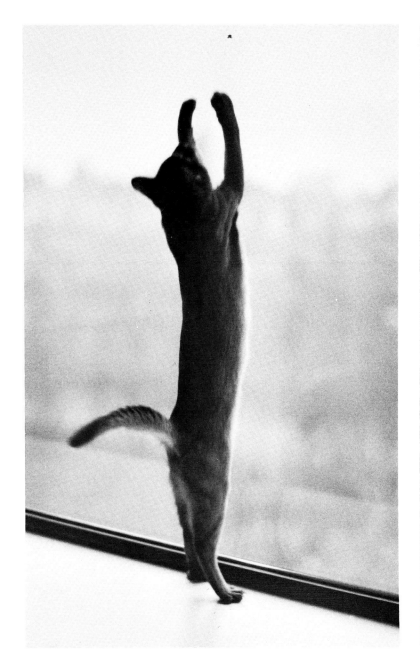
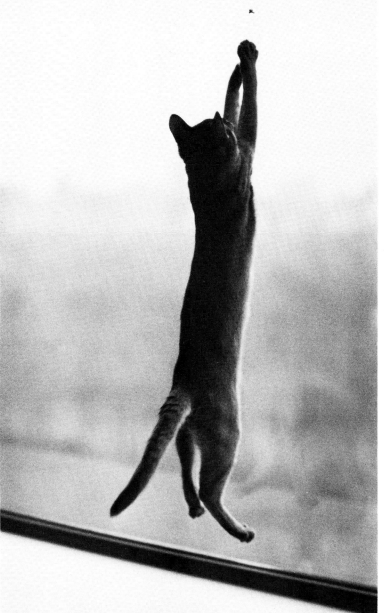

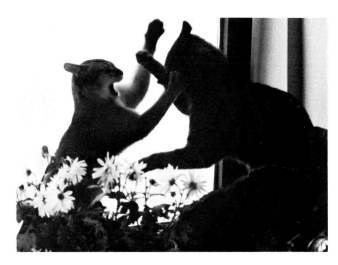

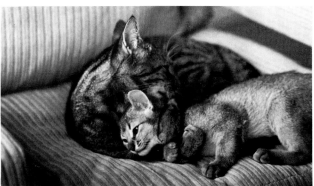

Fighting is a form of loving.

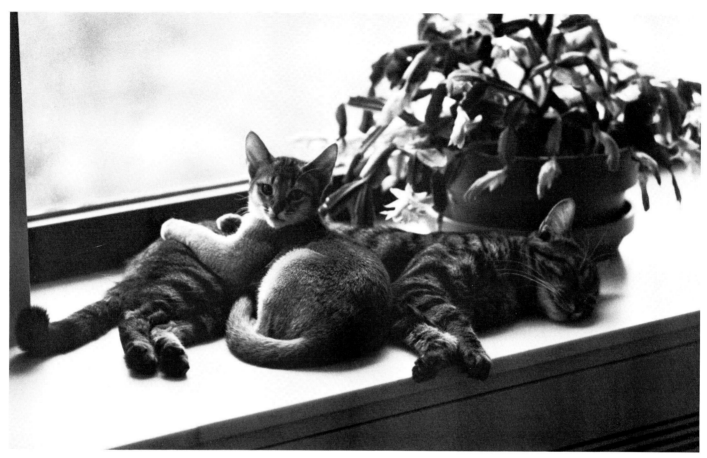

WINCHESTER and PETE

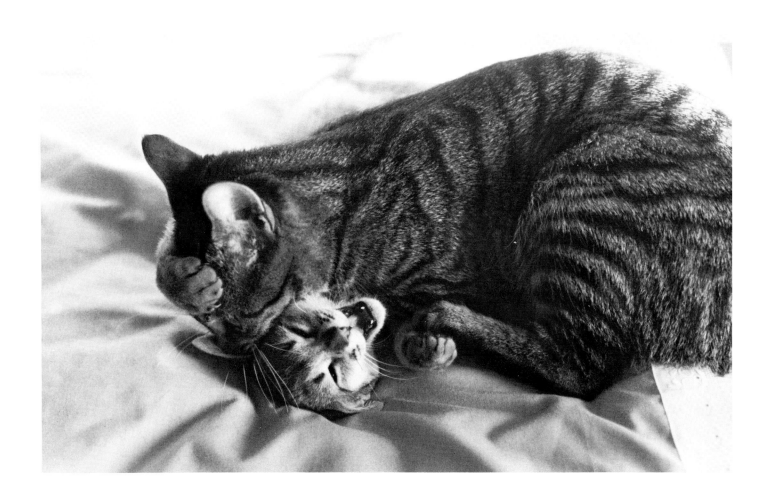

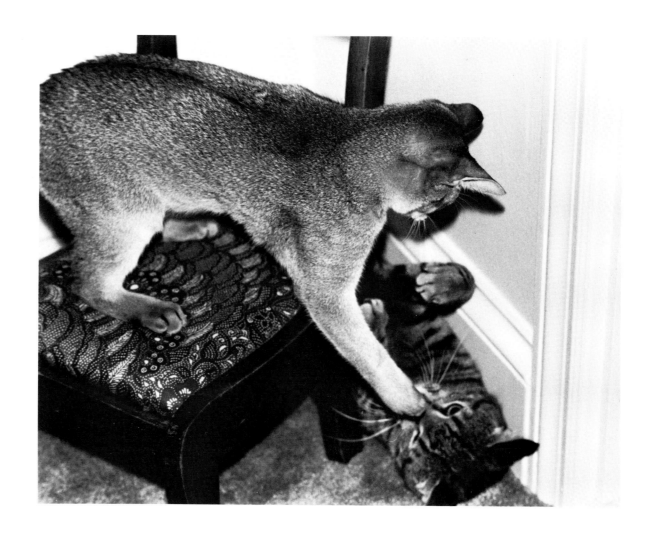

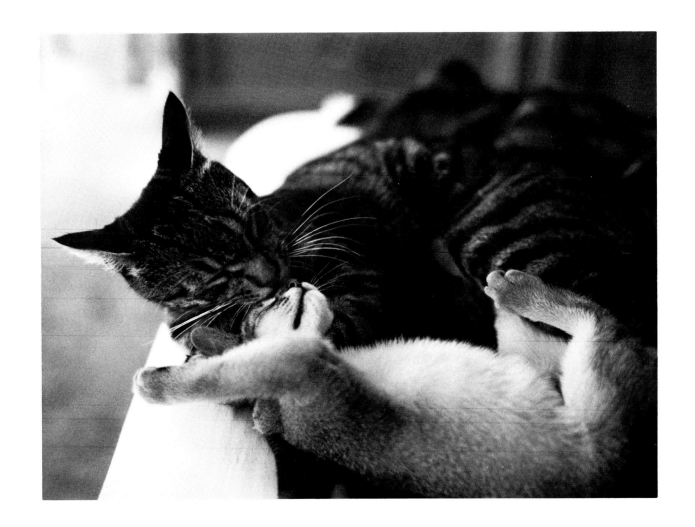

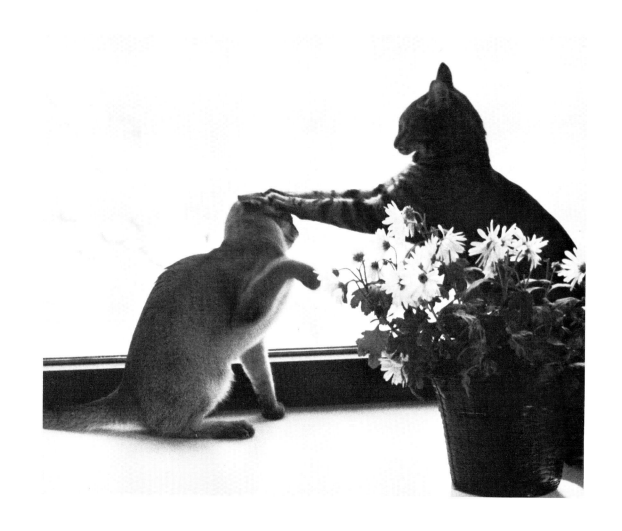

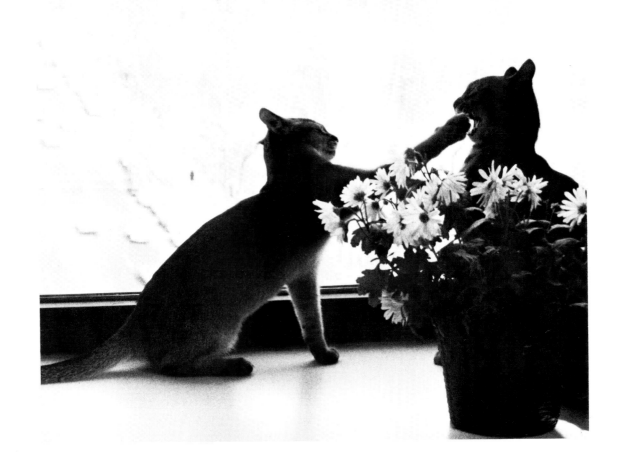

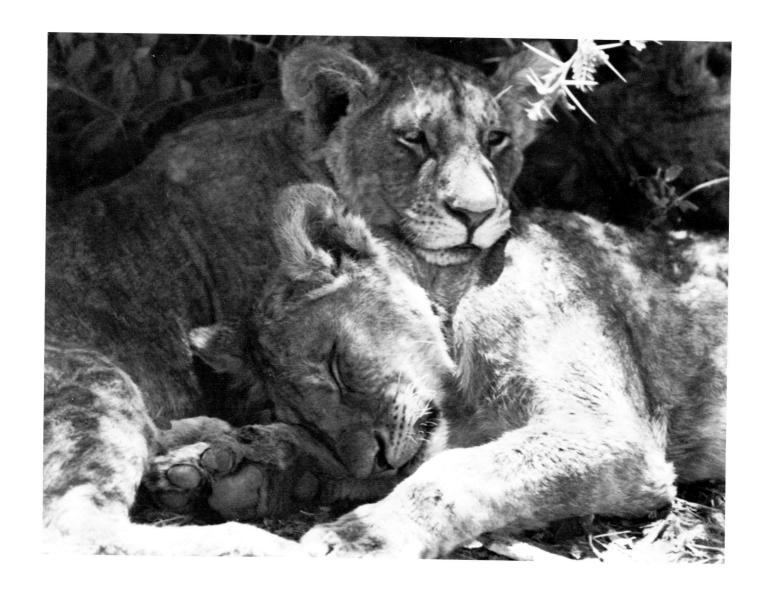

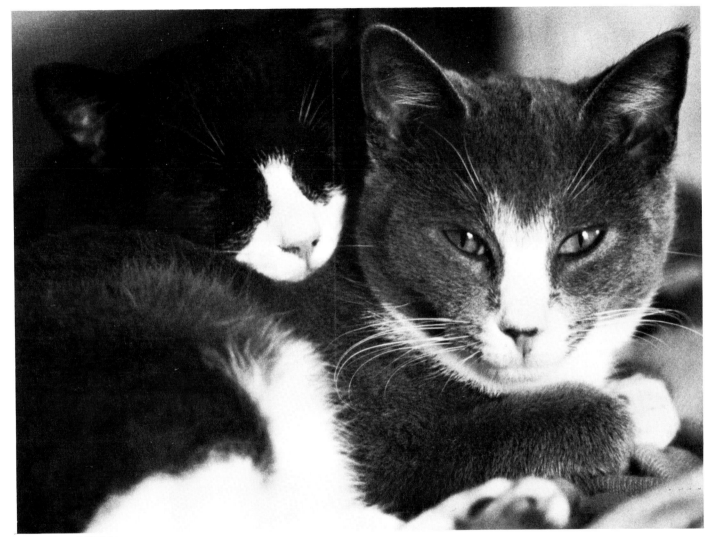

HENRY and EDNA

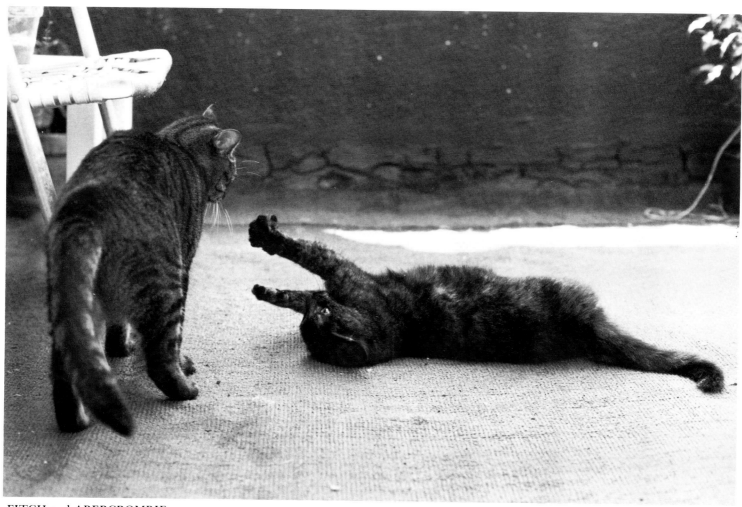

FITCH and ABERCROMBIE

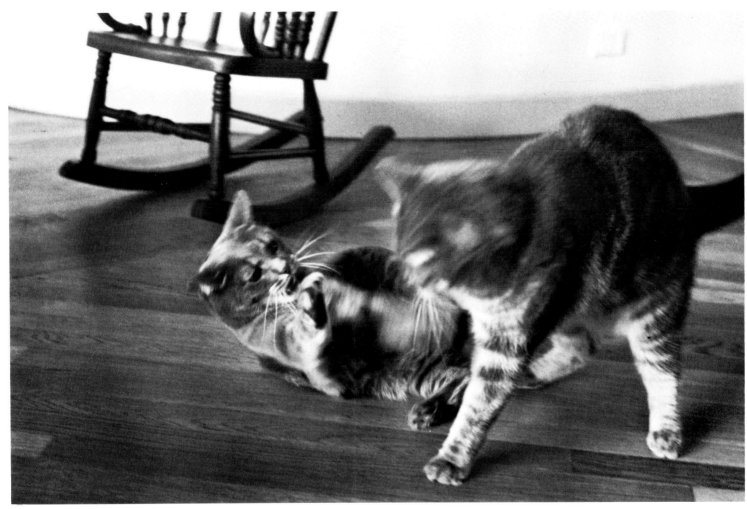

MITTENS and CLAWS

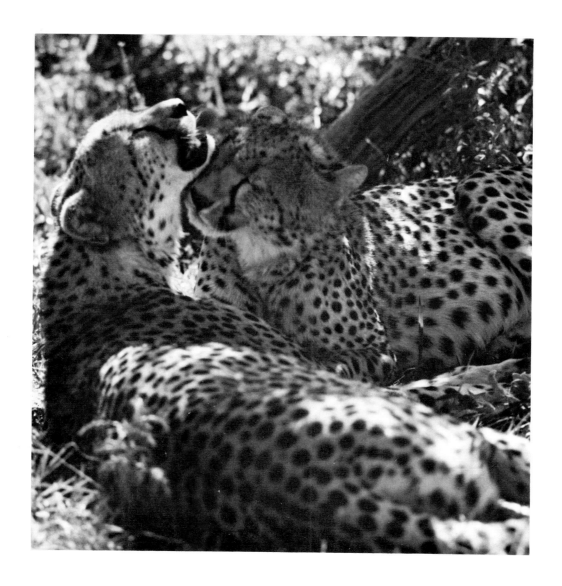

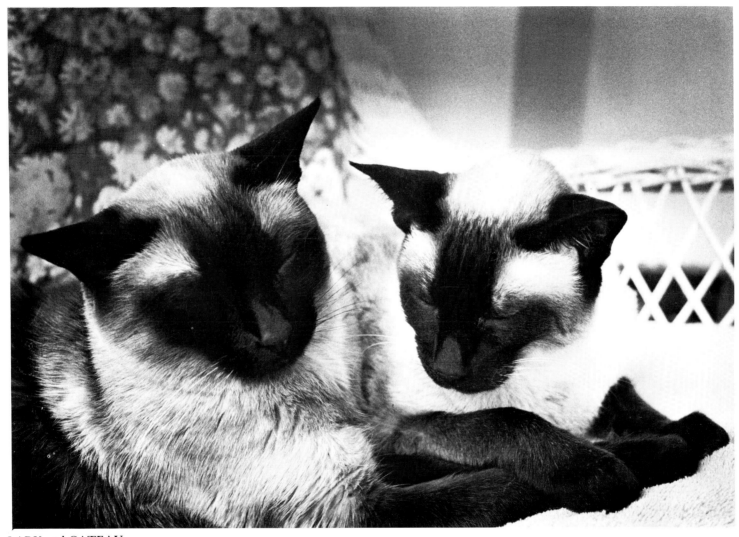

LADY and GATEAU

BELLS

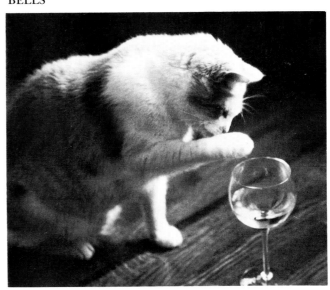

Cats are like that.

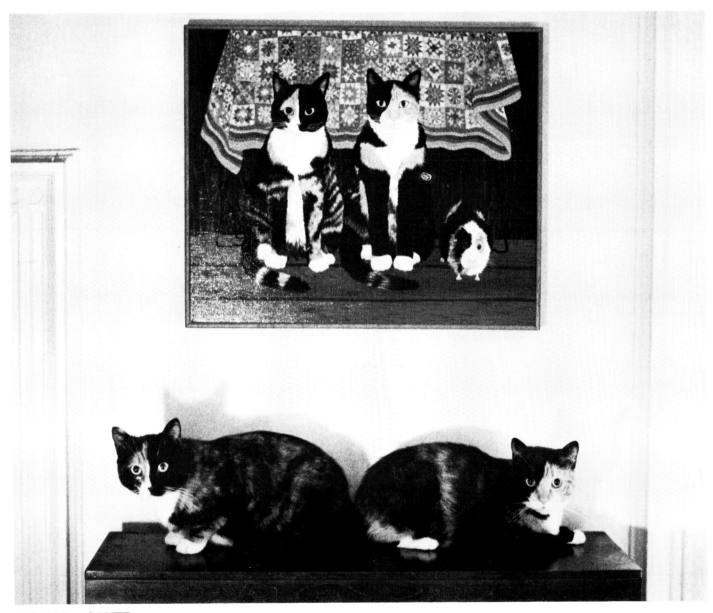

PICASSO and PUTZ

JINGLE

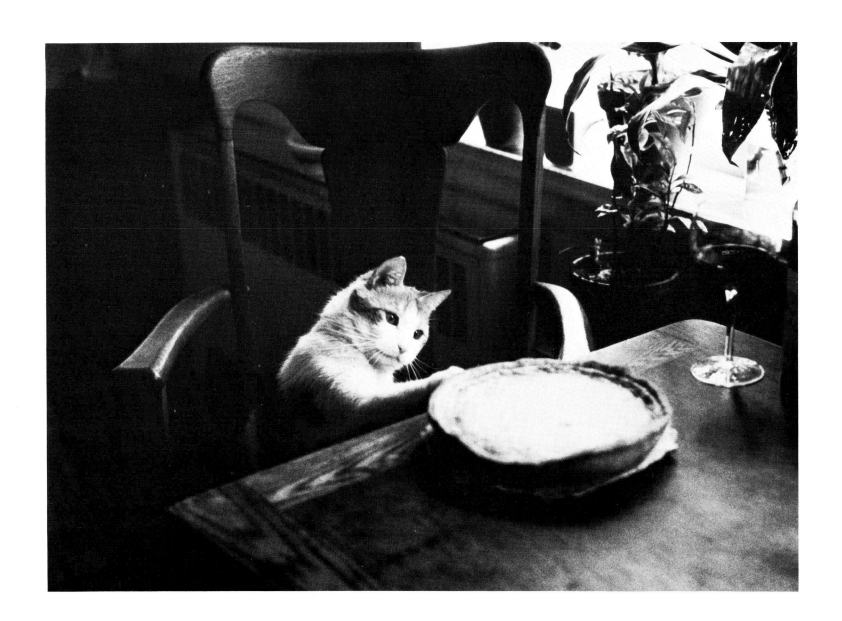

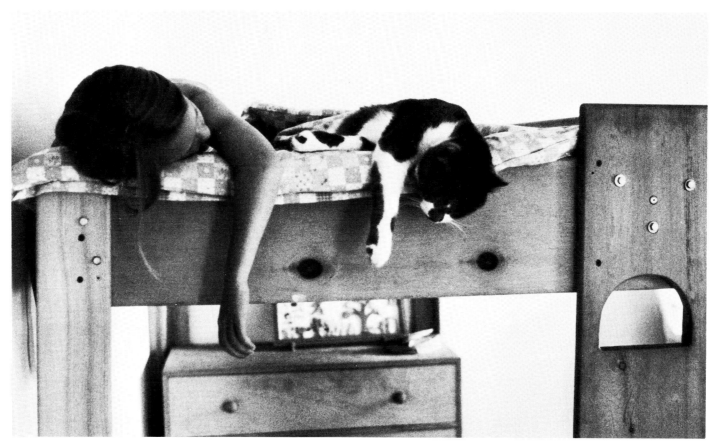

JAMIE and WINNIE

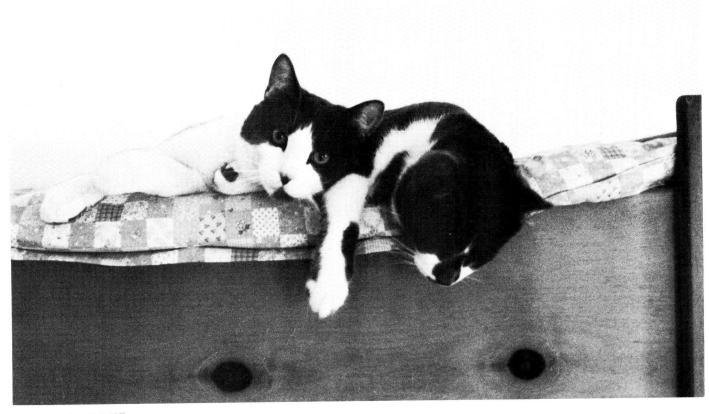

POOH and WINNIE

97

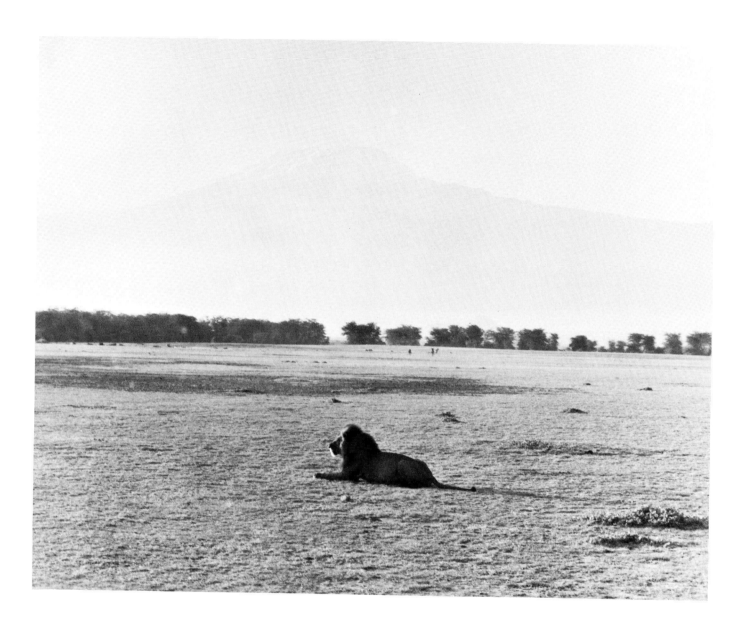

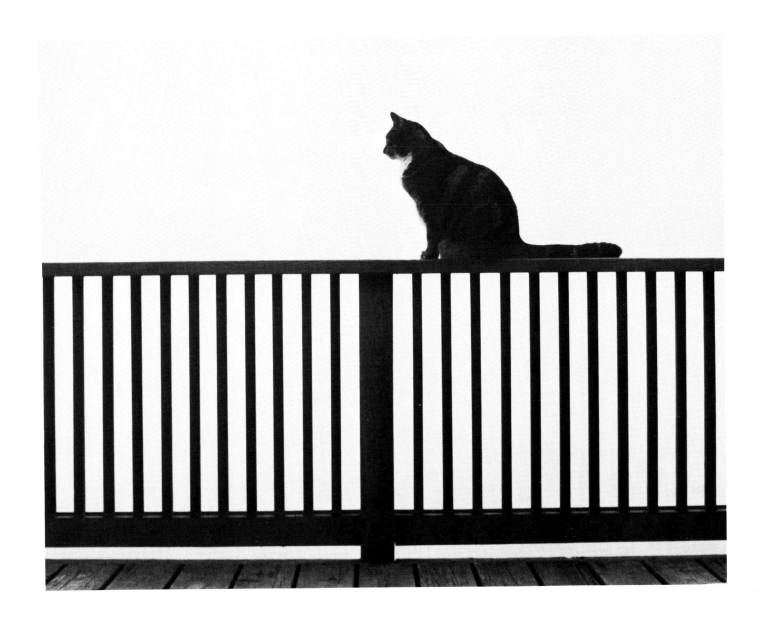

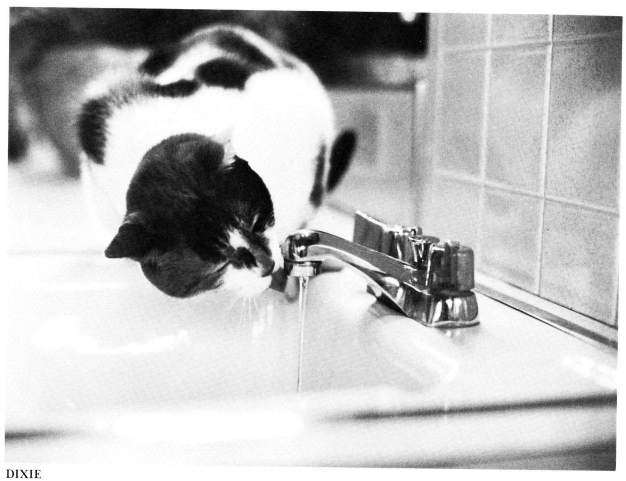

DIXIE

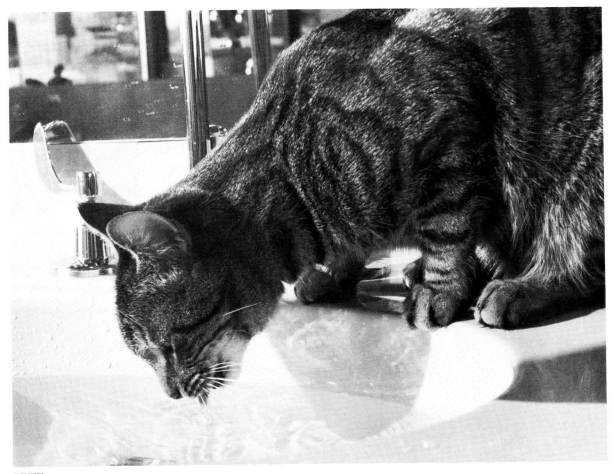

PETE

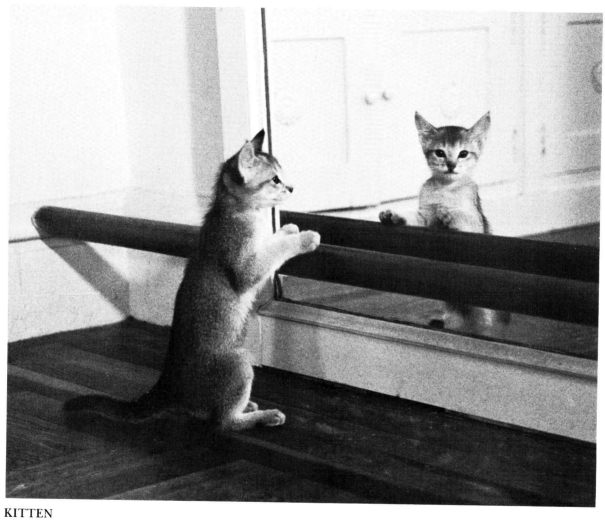

KITTEN

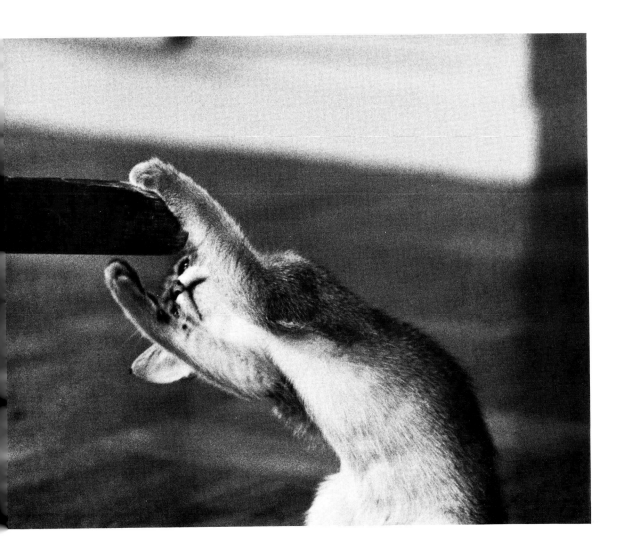

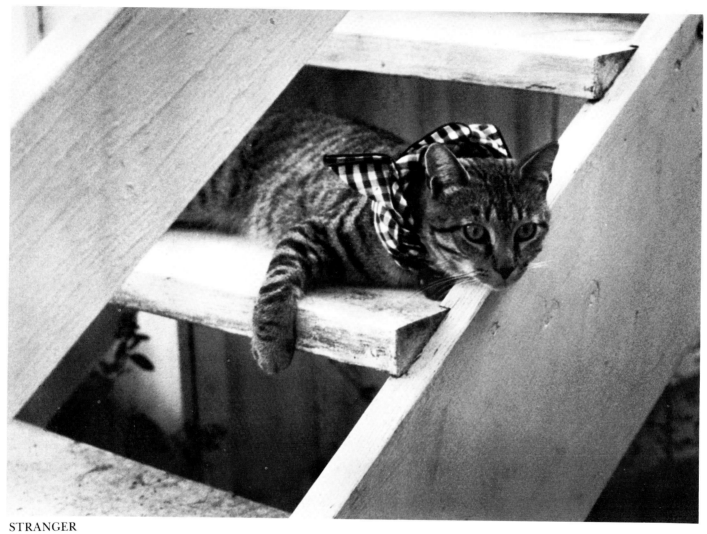

STRANGER

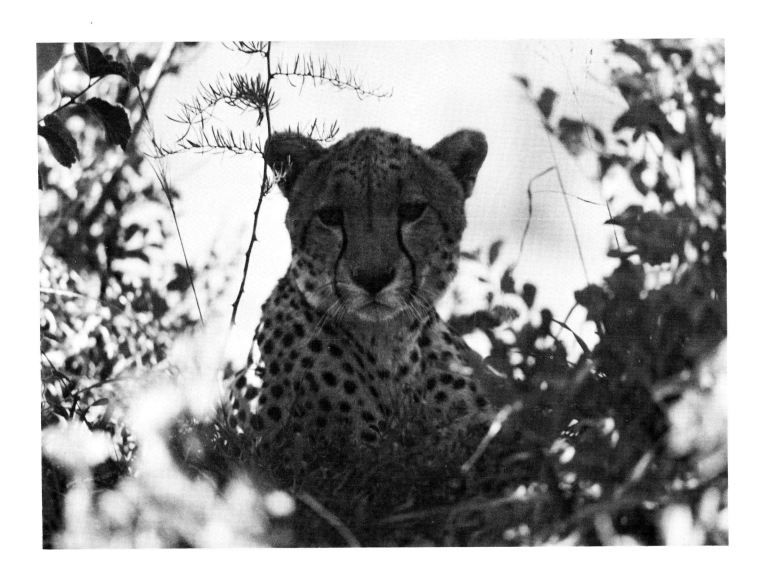

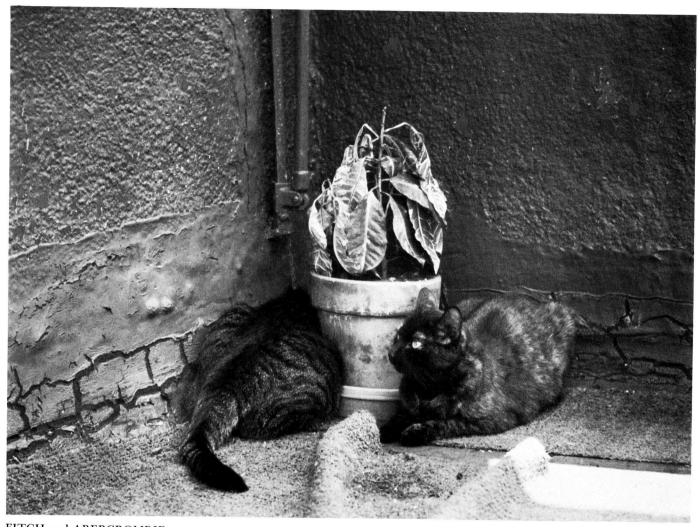

FITCH and ABERCROMBIE

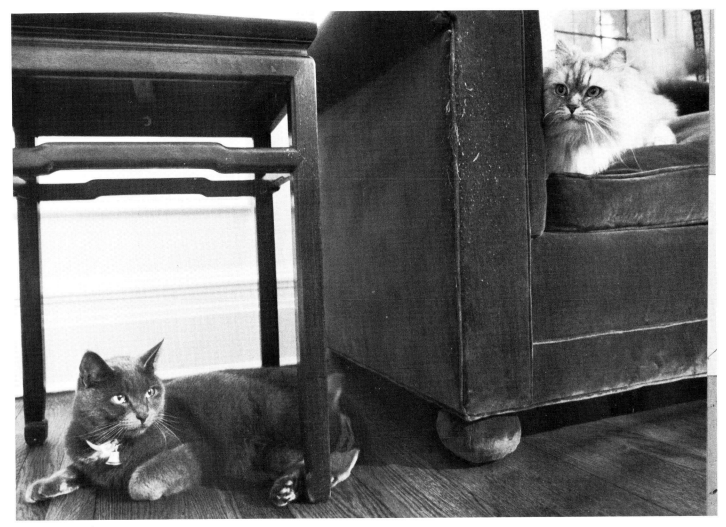

BOOTSIE and FLUFFY

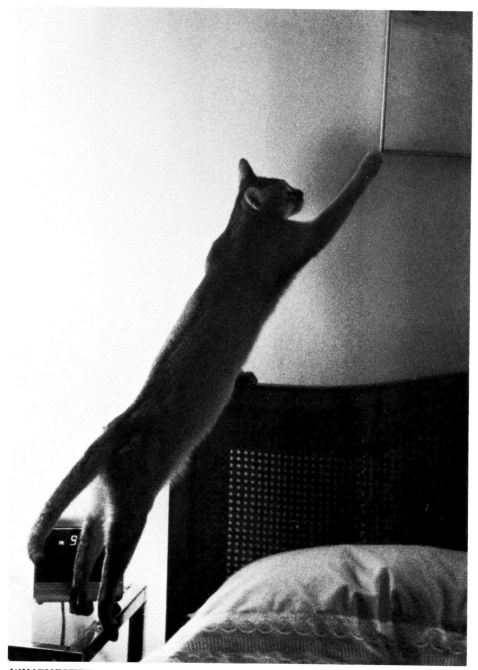

WINCHESTER

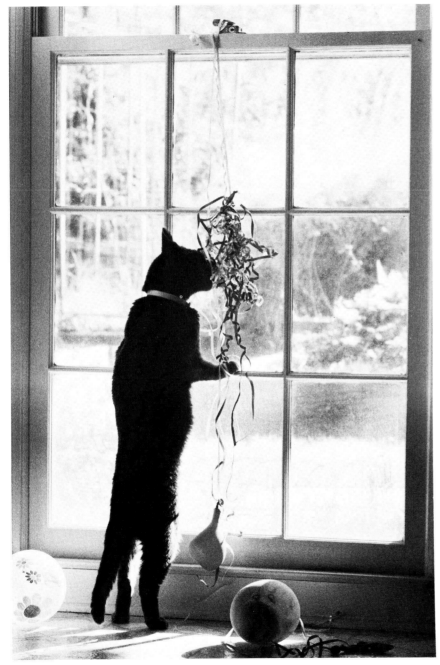

MOUSE

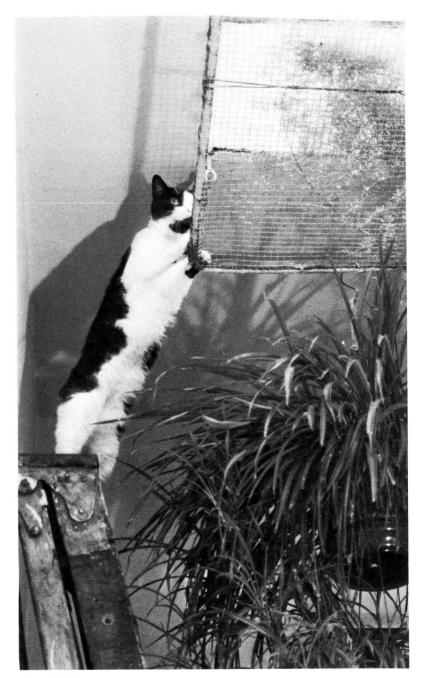

GEORGIE

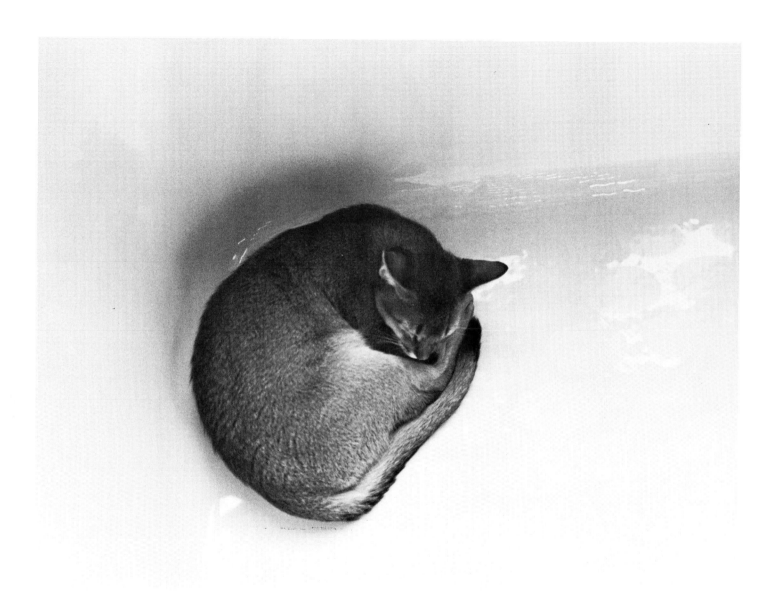

WINCHESTER

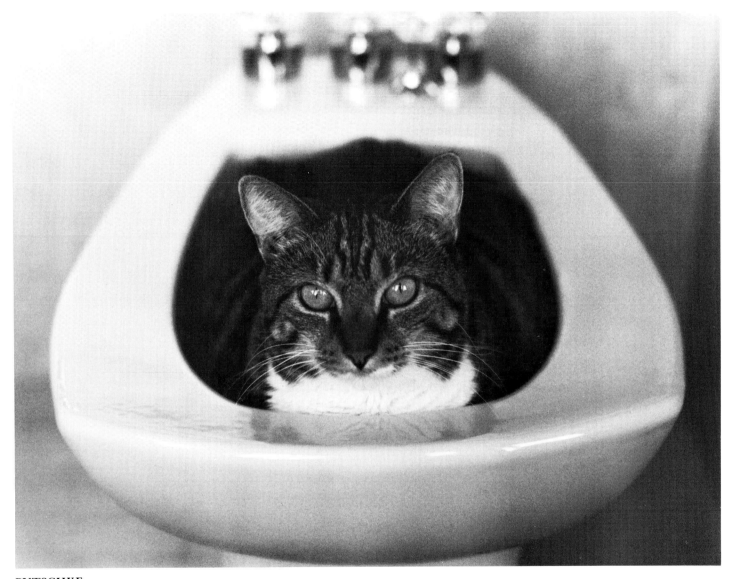

PUTSCHKE

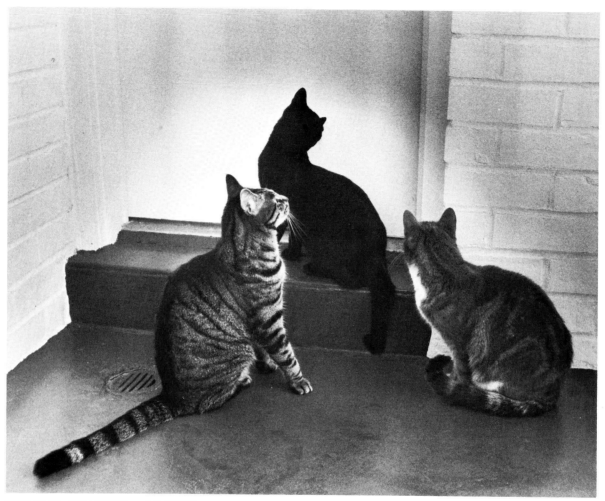

CHARLIE, SHADOW and CATTY

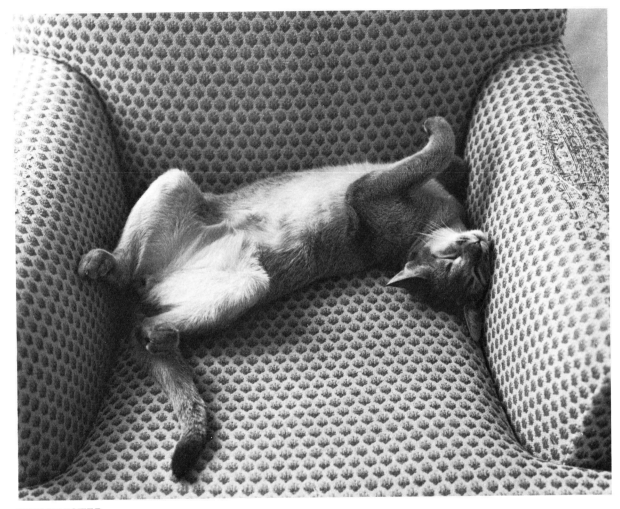

WINCHESTER

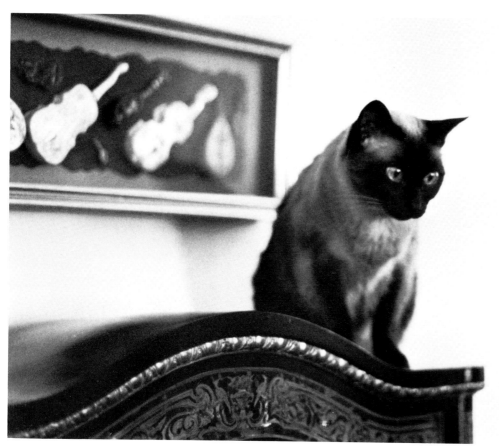

LADY

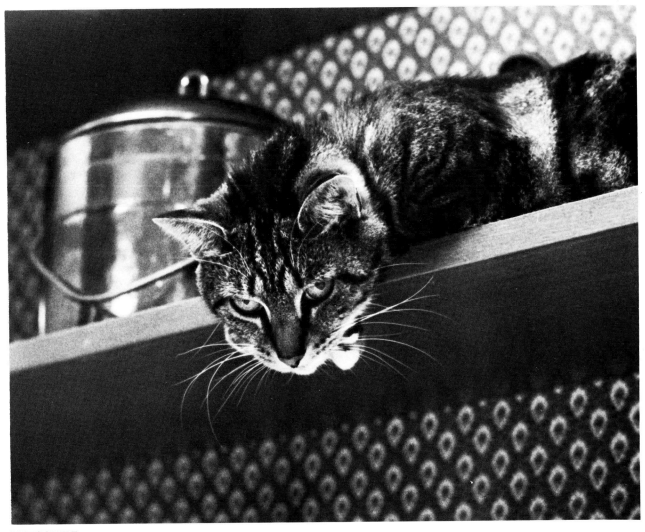

PUTSCHKE

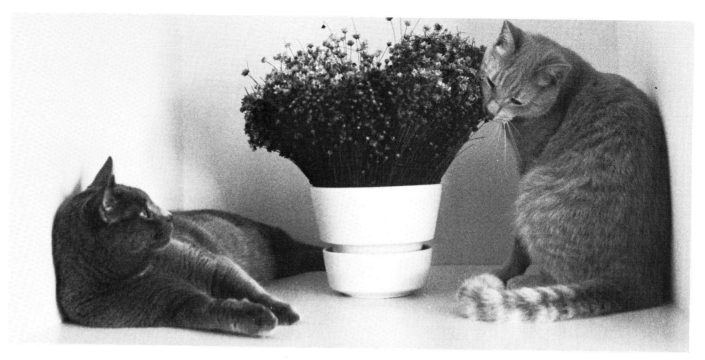

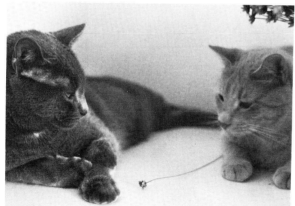

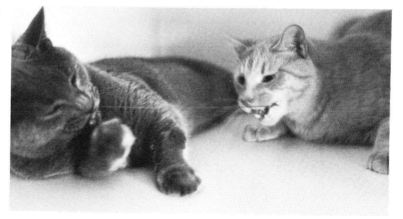

MICHAEL and PATRICK CATZ

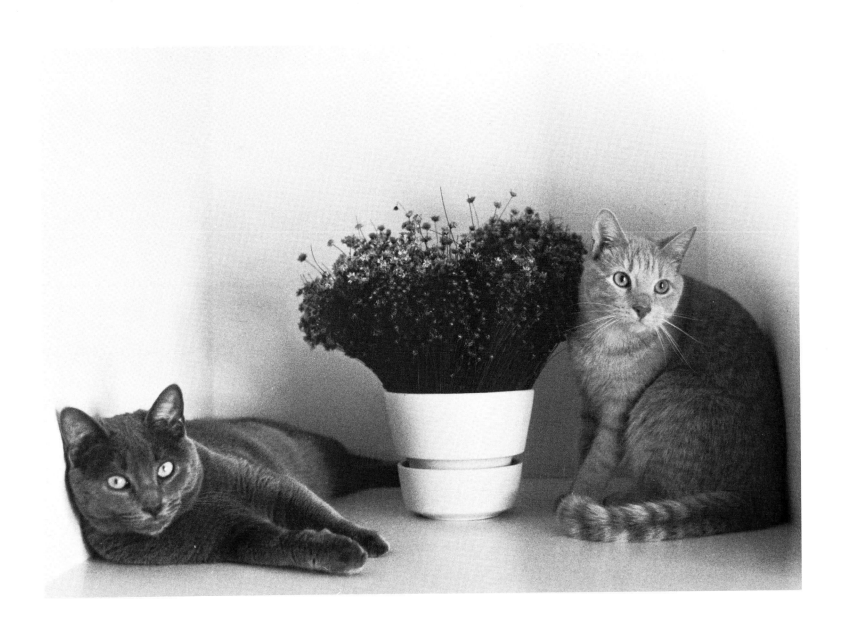

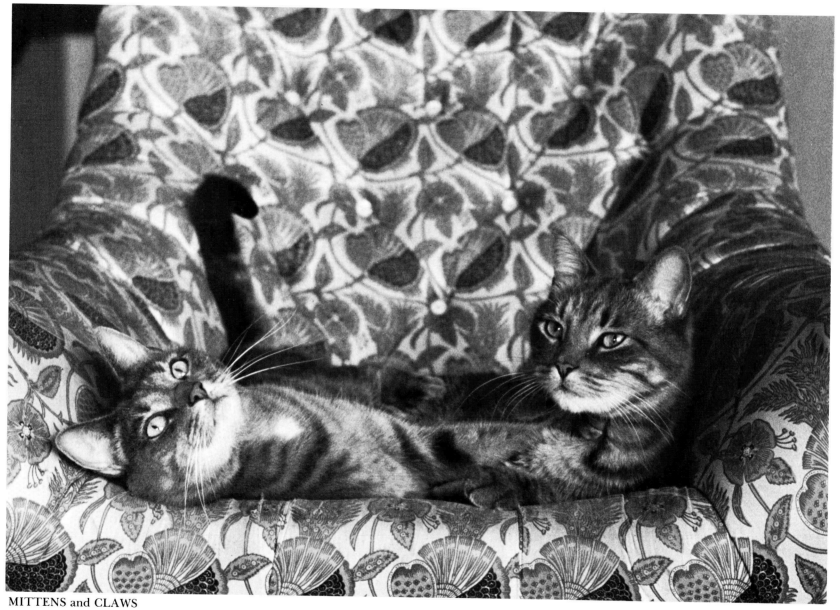

MITTENS and CLAWS

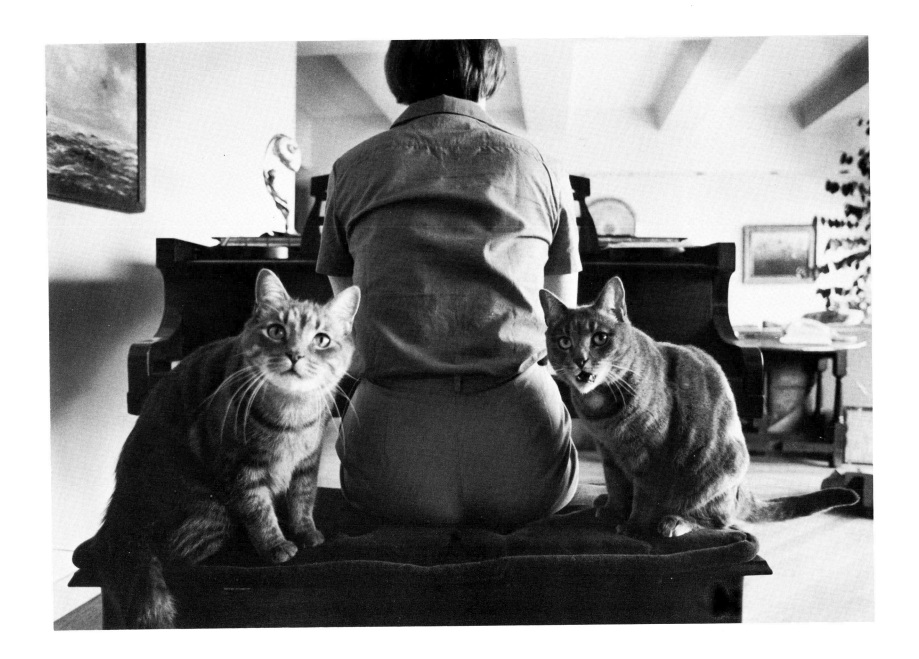

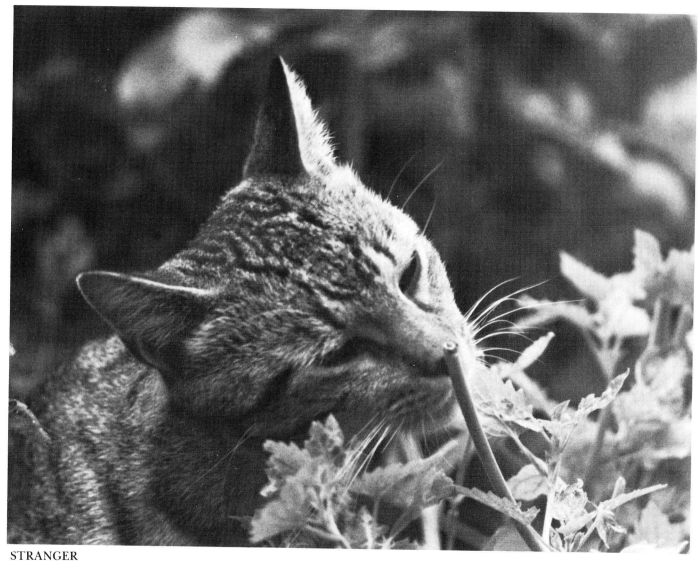

STRANGER

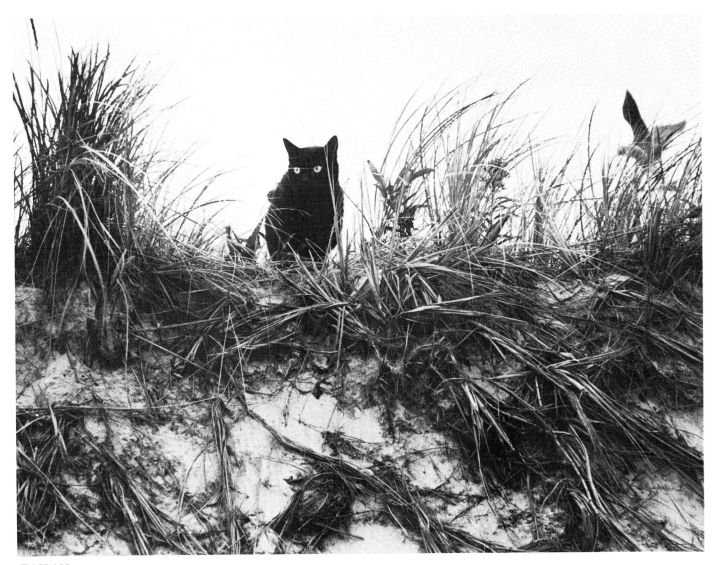

TAIPAN

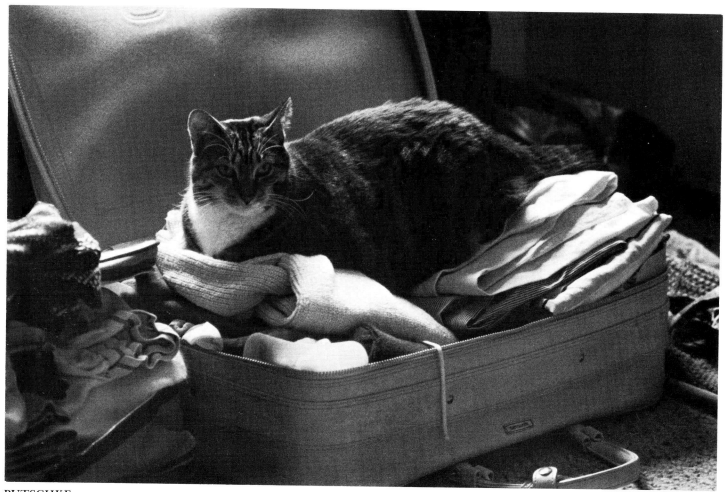

PUTSCHKE

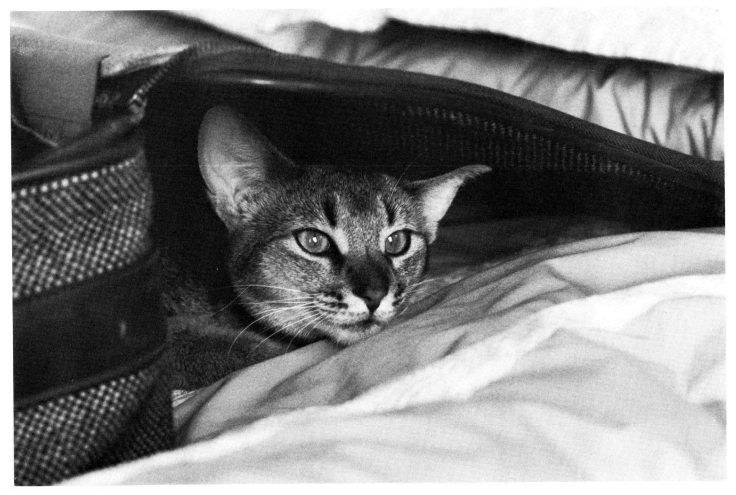

WINCHESTER

Pets and People

ABIGAIL JoAnne Putnam, Raleigh, North Carolina

ADELAIDE Walter Mathews, New York, New York

ARLO Terry and Michael Baron, New Orleans, Louisiana

BARNABY Ms. Phyllis S. Levy, New York, New York

BELLS Ray Dobbins, New York, New York

BOO Jean-Claude Mastriani, New York, New York

BOOTSIE AND FLUFFY Robyn Binstein and Liz Goldsmith, Englewood, New Jersey

C_2 Paul and Ann Hill, Atlanta, Georgia

CHARLIE, SHADOW AND CATTY Abigail and Arthur Morrison, Riverdale, New York

DIXIE Kay and Robert Johnson, Tucker, Georgia

FERNANDO Pat and Frank Schwab, Pound Ridge, New York

FITCH AND ABERCROMBIE Cynthia Kaplan and David Smith, Brooklyn, New York

GEORGIE Clara Graedel, New York, New York

HEATHCLIFFE AND OLMO Suzanne Levine and Robert Levine, New York, New York

HENRY AND EDNA Jane Howard, New York, New York

HUDSON Larry Ashmead and Walter Mathews, New York, New York

JAMIE AND WINNIE James and Christine Schwab, Pound Ridge, New York

JINGLE Ray Dobbins, New York, New York

KITTEN Phyllis Goldman, New York, New York

LADY AND GATEAU Addy and Gary Fieger, New York, New York

LOUFI AND HER KITTENS Dr. and Mrs. Jean-Pierre Farcy, Piermont, New York

MICHAEL AND PATRICK CATZ Amy Saypol, New York, New York

MITTENS AND CLAWS Terry and Hugh Herbert-Burns, New York, New York

MOUSE Paul and Ann Hill, Atlanta, Georgia

NEIGHBOR Lizzy and Jim Hogan, New Orleans, Louisiana

PICASSO AND PUTZ Mimi Vang Olsen, New York, New York

POOH AND WINNIE James and Christine Schwab, Pound Ridge, New York

SCAT Kitty and Jack Krumpe, Glen Head, New York

SNOWFLAKE June Peretti, Old Tappan, New Jersey

STRANGER Betsy Nolan, Stuyvesant Falls, New York

TAIPAN Eleanor Friede, New York, New York

VISITOR Lynne and Paul Bloch, Englewood, New Jersey

WINCHESTER, PUTSCHKE (back cover), AND PETE (frontispiece)
 Joan and Howard Baron, New York, New York

WOOFI (front cover) Dr. and Mrs. Jean-Pierre Farcy, Piermont, New York

And many unnamed cats from, among other places, the Serengeti and the Bronx.